American Naive Paintings

The Edgar William and Bernice Chrysler Garbisch Collection

American Naive Paintings

The Edgar William and Bernice Chrysler Garbisch Collection

Richard J. Wattenmaker

Alain G. Joyaux

Flint Institute of Arts

December 6, 1981 - January 24, 1982

This publication has been made possible through
the generous support of the Founders Society of
the Flint Institute of Arts.

Cover:
Humming Bird, Red Bird, Baltimore Bird, Robbin, Flicker, Blue Bird 1842
Artist unknown
Catalogue no. 32, p. 72

Contents

Introduction Richard J. Wattenmaker 6

Catalogue of the Collection Alain G. Joyaux 9

Bibliography 91

Trustees and Staff of the Flint Institute of Arts 95

Introduction

American Naive Paintings: The Edgar William and Bernice Chrysler Garbisch Collection marks the first time that the Flint Institute of Arts has placed on display the gifts received from Colonel and Mrs. Garbisch in their totality. These paintings, watercolors and miniatures were presented in stages over a period of thirteen years. Ten paintings were donated in 1968, six in 1972 and nine more were added in 1973. In 1981, following the death of these generous donors, I had the pleasure of participating in the selection of an additional fifteen works which had been bequeathed to the Art Institute. The catalogue of the present exhibition will thus serve as a permanent record of the Garbisches' enrichment of our collections while it also publishes and reproduces thirty of the forty works for the first time.

The Garbisches maintained a longstanding interest in the field of early American art, of which their collecting activities in the area of naive painting was but one dimension of a much wider range of interests. Since 1954 selections from their considerable collection have been exhibited in many art museums throughout the country and as early as 1953 Colonel and Mrs. Garbisch had donated an important group of works to the National Gallery of Art, Washington, D.C. As the collection continued to grow, the Garbisches consistently shared their treasures by means of exhibitions and publications which informed the public about a scarcely known but intriguing aspect of the indigenous material culture of the United States. By means of the numerous traveling exhibitions of paintings, watercolors and pastels from the Garbisch Collection, much serious interest on the part of museums, scholars and collectors was generated, with the consequent reevaluation which has occurred over the past two decades. This educative function was expanded by exhibitions of works from the collection which were sent to tour abroad. In 1958, a selection was shown in the *American Folk Art* exhibition at the Worlds Fair in Brussels. Subsequent exhibitions took place in Canada, France, Germany, Italy, England, Spain, Sweden and Japan, where audiences were introduced to the special character of American naive painting and were able to relate it to their own contemporaneous traditions of Folk painting. Several of the works which have been given to Flint were seen in those exhibitions.

The variety of subjects chosen for the Flint Institute of Arts enhances the attraction of the donation: portraits, scenes illustrating popular novels of the period, pastoral and imaginary landscapes, genre subjects, still lifes and flowerpieces, as well as The Crucifixion and a portrait of George Washington dated 1849, provide a well-rounded cross-section of the work of naive painters in America from *circa* 1800-1870. Of particular interest to Flint is a large factory scene of Newport, Rhode Island and a depiction of an early steam-driven tricycle. These creations appeal directly to us in what they reveal and preserve of our ancestors and their customs. They express in straightforward, colorful compositions, filled with picturesque details, the robustness and diversity of the creative rather than the practical side of our national life. Indeed, their imagery has become indelibly identified with our present day conception of that earlier life as it was experienced in the cities and on the frontiers of the growing nation.

We should like to express our appreciation to the following who have assisted us in gathering documentation for this exhibition: Laurie Weitzenkorn, Intern, Department of

American Art, National Gallery of Art, Washington, D.C., Mrs. Georgiana B. Ralph of the Wallingford Public Library, Wallingford, Connecticut, and the staffs of the Department of Art and Maps, Michigan State University Libraries and the Art, Music and Drama Department of the Flint Public Library.

Joseph Zayac of the Flint Institute of Arts staff made the color transparency which appears on the cover and Michelle Fournier Smith contributed the black and white photographs of the works of art which appear herein.

Barbara F. Gerholz, Business Manager, and Mary Helen Pascoe, Membership Secretary/ Public Relations, have made essential contributions to the production of this publication. I should also like to acknowledge the work of staff members Christopher Young, Curator, and Jerl Richmond, Preparator, for their work on the collections and the exhibition.

Our thanks to Clifford Schaefer, Curator of the Edgar William and Bernice Chrysler Garbisch Collection, for his assistance and responses to our many inquiries. Alain G. Joyaux, Assistant to the Director, has been responsible for the entries on the individual works in the exhibition and for the overall supervision of the design and production of the catalogue.

Richard J. Wattenmaker
Director
Flint Institute of Arts

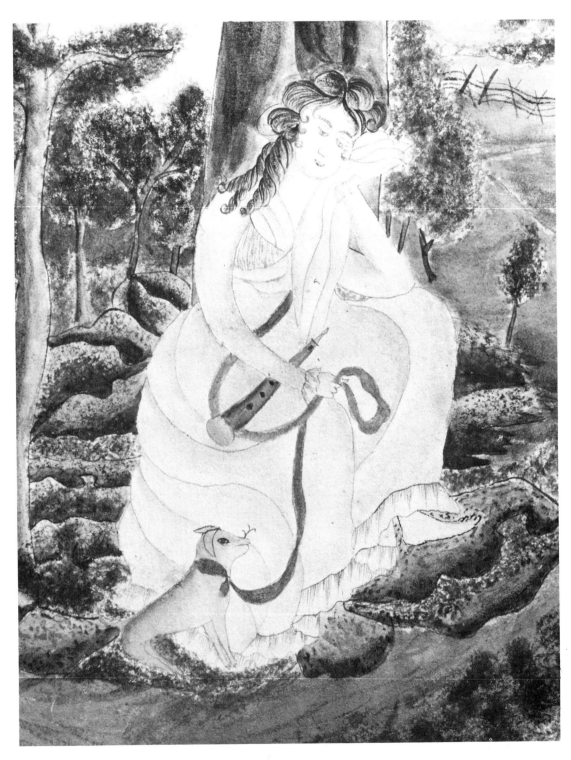

Catalogue no. 7, detail

Catalogue of the Collection

Title: Additional titles the work has been known by, or published as, appear in italics, otherwise information within parentheses refers to the sitter, place, etc.

Dimensions: Height precedes width. Multiple dimensions refer to paper and image respectively.

Inscriptions: Unless otherwise noted, there is no reason to believe that they are by the artist.

Provenance: Earliest provenances most often represent the verbal or otherwise recorded general origin of the work prior to its acquisition by those listed. Garbisch collection numbers preceded by an X denote frames which were acquired separately.

Frames: Original frames, those contemporary with the approximate date of the work and reproductions are so listed. Width precedes depth of the molding. Profiles are reproduced at one-third of original size.

Unknown

Lady with Passion Flower and Nasturtium ca. 1800
(Lady Holding Anemones)

oil on canvas 72.8 x 55 cm
unsigned

PROVENANCE:
New York; Argosy Gallery, New York, New York;
purchased from Argosy Gallery by Edgar William and
Bernice Chrysler Garbisch, April 3, 1958 (Garbisch
58.6 also X1022); Flint Institute of Arts, December
1972.
FIA 72.74

CONDITION:
Cleaned, relined and in-painted by Paul P. Kiehart,
1958.

FRAME:
contemporary 7.5 x 7.6 cm (7.5 x 6.1 cm orig.)
The face is gilded, its inner surface decoratively
molded. The outside edge is painted an ochre tone.
The depth of the molding was increased at a later
date.

EXHIBITIONS:
Battle Creek Civic Art Center, *Heritage of American
Art*, Oct. 5-30, 1975, no. 8.

Catalogue no. 1

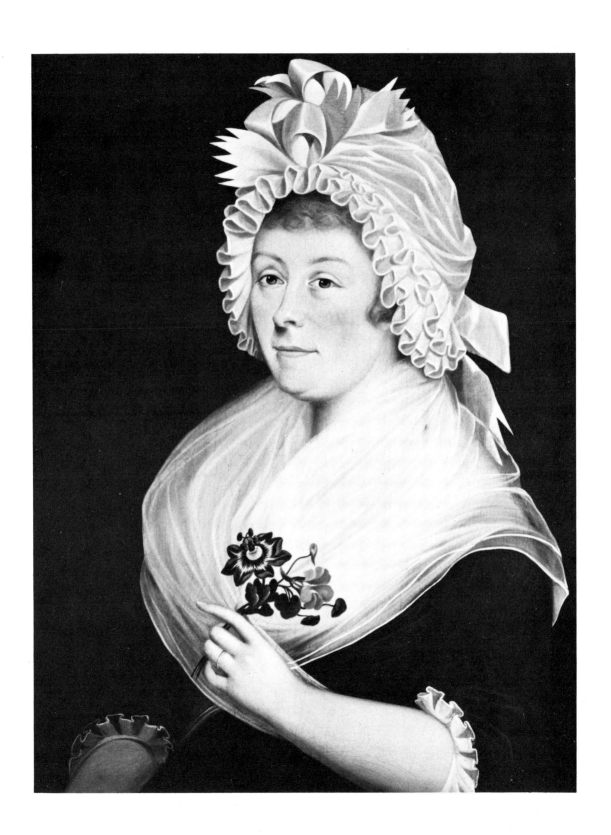

Unknown

Portrait of a Man ca. 1800
(Portrait of Man wearing white stock and red-trimmed white waistcoat)

oil on canvas 53.3 x 43.4 cm
unsigned

PROVENANCE:
New York; Thurston Thacher, Hyde Park, New York; purchased from Thacher by Edgar William and Bernice Chrysler Garbisch, July 10, 1961 (Garbisch 61.68 also X497); Flint Institute of Arts, December 1973.
FIA 73.92

CONDITION:
Cleaned, relined, adhered to a honeycomb panel and in-painted by Paul P. Kiehart, 1968.

FRAME:
contemporary 9.5 x 5.2 cm
The face is gilded, the outside edge painted an ochre tone.

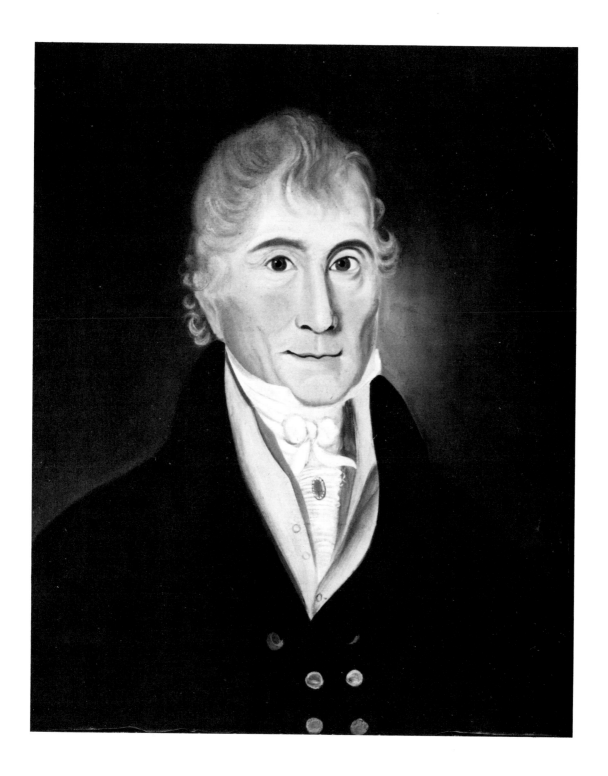

Catalogue no. 2

Unknown

Elisha Faxon 1808*
(companion to 81.15)
(Man Facing Left)

watercolor on paper
16.3 x 14.2 cm 12.2 x 10.2 cm
unsigned

PROVENANCE:
Connecticut; F. W. Tuessenech; purchased from
Tuessenech by Edgar William and Bernice Chrysler
Garbisch, February 10, 1949 (Garbisch 49.39); Flint
Institute of Arts, February 1981.
FIA 81.13

CONDITION:
Cleaned and lined with a thin oriental paper by
Christa M. Gaehde, 1962.

FRAME:
original 3.2 x 2.8 cm
The face and outside edge are gilded. The outside
edge bears a decoratively molded rib.
*The back of the frame bears remnants of a piece of
brown backing paper inscribed: *Elisha Faxon, father
of drawn 1808*

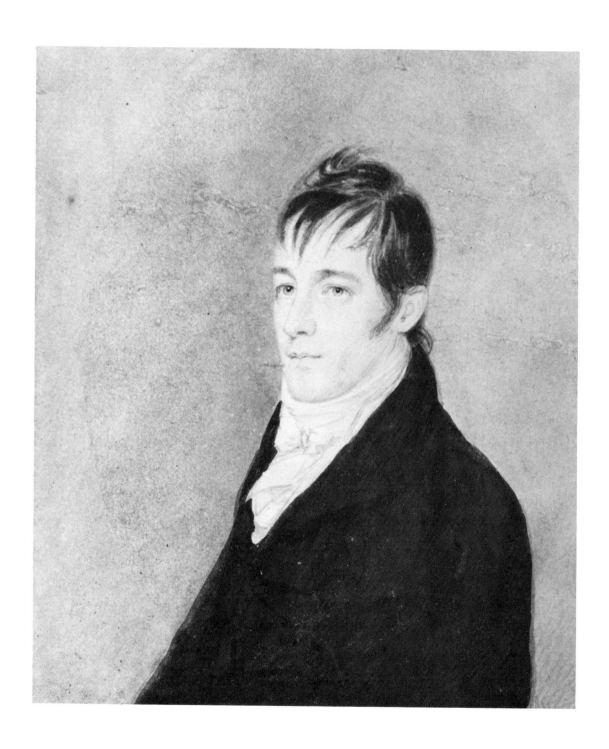

Catalogue no. 3

Unknown

Elizabeth Faxon ca. 1808*
(companion to 81.13)
(Girl Facing Right)

watercolor on watermarked (John Fellows) paper
16.3 x 14.4 cm 12.2 x 10.5 cm
unsigned

PROVENANCE:
Connecticut; F. W. Tuessenech; purchased from
Tuessenech by Edgar William and Bernice Chrysler
Garbisch, February 10, 1949 (Garbisch 49.41); Flint
Institute of Arts, February 1981.
FIA 81.15

CONDITION:
Cleaned and lined with a thin oriental paper by
Christa M. Gaehde, 1962.

FRAME:
original 3.2 x 2.8 cm
The face and outside edge are gilded. The outside
edge bears a decoratively molded rib.
*See 81.13

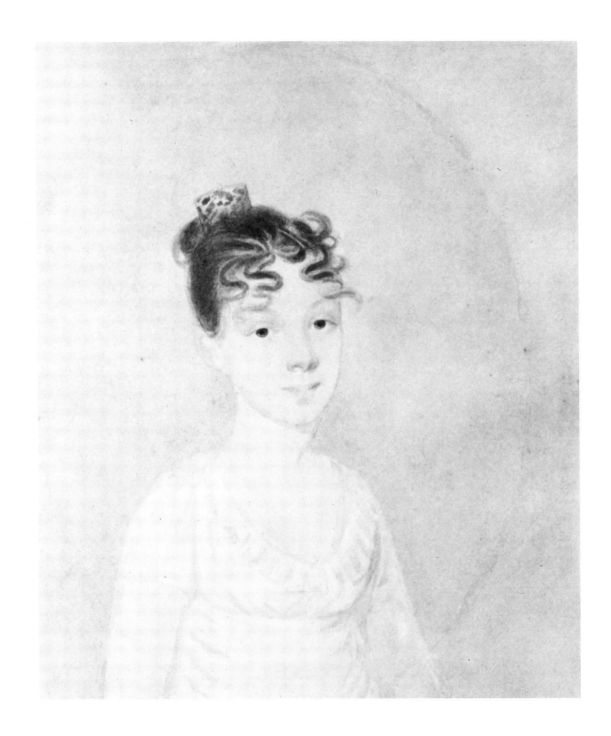

Catalogue no. 4

Unknown

Mrs. James Olcott ca. 1808*
(companion to 81.13 — 81.15?)
(*Woman with White Cap*)

watercolor on watermarked (John Fellows) paper
12.4 x 10.3 cm
unsigned

PROVENANCE:
Connecticut; F. W. Tuessenech; purchased from
Tuessenech by Edgar William and Bernice Chrysler
Garbisch, February 10, 1949 (Garbisch 49.38); Flint
Institute of Arts, February 1981.
FIA 81.14

CONDITION:
Cleaned and lined with a thin oriental paper by
Christa M. Gaehde, 1962.

FRAME:
original 3.2 x 2.8 cm
The face and outside edge are gilded. The outside
edge bears a decoratively molded rib.
*See 81.13

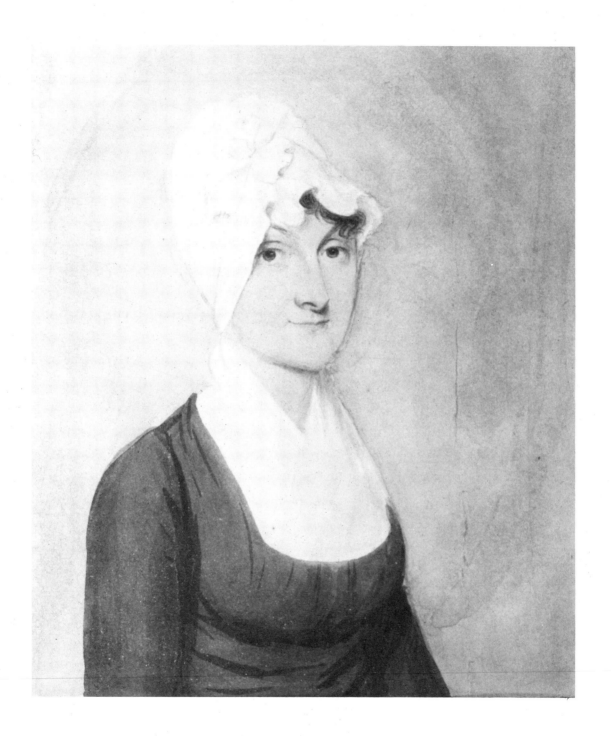

Catalogue no. 5

Unknown

Margaret Ervin in Pink Dress 1810
(Lady in Pink Dress)

oil on canvas 62.7 x 53.6 cm
unsigned
inscribed in ink, verso of original canvas:
Margaret Ervin 1810 Painted 1810

PROVENANCE:
Colorado; H. Gregory Gulick; purchased from
Gulick by Edgar William and Bernice Chrysler Gar-
bisch, November 16, 1954 (Garbisch 54.138 also
Gar 447); Flint Institute of Arts, February 1981.
FIA 81.10

CONDITION:
Cleaned, relined and in-painted by Alberto Angeli,
1955.

FRAME:
original 7.8 x 5.4 cm
The face is gilded, the outside edge painted a sienna
tone. The back of the frame bears remnants of a New
York City newspaper dated April 1836.

EXHIBITIONS:
Washington, D.C., National Gallery of Art, on
loan, 1959-1980.

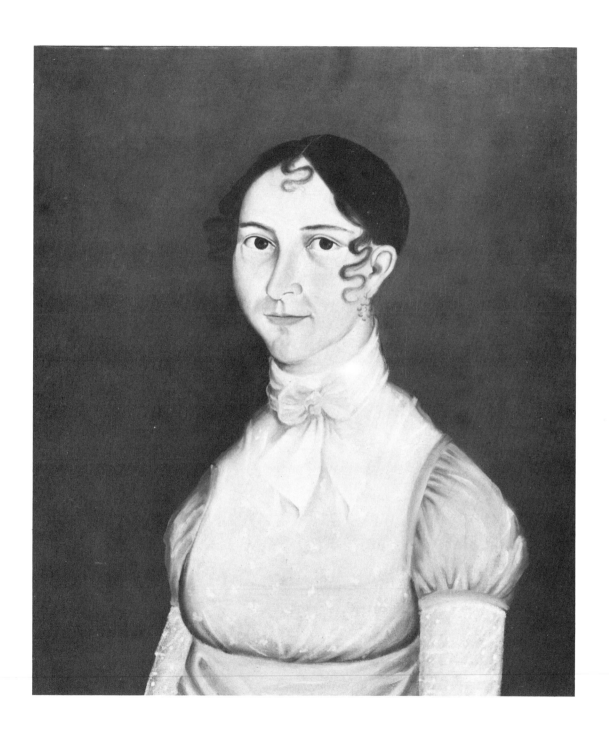

Catalogue no. 6

Eunice Pinney, attributed to
born February 9, 1770 Simsbury, Connecticut
died 1849 Simsburry?, Connecticut

Maria ca. 1810
(*Maiden Under Tree with Lamb*
and *Woman Under Tree*)
("Poor" Maria, a character from *The Life and
Opinions of Tristram Shandy, Gentleman,* Book IX,
and *A Sentimental Journey Through France and Italy,*
by Laurence Sterne, 1767 and 1768 respectively)

watercolor on paper 36.8 x 37 cm
unsigned

PROVENANCE:
New York; The Old Print Shop, New York, New
York; purchased from The Old Print Shop by Edgar
William and Bernice Chrysler Garbisch, June 28,
1950 (Garbisch 50.59 also X1067); Flint Institute of
Arts, February 1981.
FIA 81.11

CONDITION:
Cleaned and lined with a thin oriental paper by
Christa M. Gaehde, 1959.

FRAME:
contemporary 6.2 x 3.6 cm
The face is gilded, the outside edge stained grey.

"____ They were the sweetest notes I ever heard;
and I instantly let down the fore-glass to hear them
more distinctly ____ 'Tis *Maria;* said the postillion,
observing I was listening ____ Poor *Maria,* continued
he (leaning his body on one side to let me see her, for
he was in line betwixt us), is sitting upon a bank
playing her vespers upon her pipe, with her little
goat beside her."[1]

"When we had got within a half league of
Moulines, at a little opening in the road leading to a
thicket, I discovered poor *Maria* sitting under a pop-
lar ____ she was sitting with her elbow in her lap,
and her head leaning on one side within her hand
____ a small brook ran at the foot of the tree.

She was dress'd in white, and much as my friend
described her, except that her hair hung loose,
which before was twisted within a silk net. ____ She
had, superadded likewise to her jacket, a pale green
ribband, which fell across her shoulder to the waist;
at the end of which hung her pipe."[2]

[1]Laurence Sterne, *The Life and Opinions of Tris-
tram Shandy, Gentleman* (London: Dent, 1978),
p. 465.

[2]Laurence Sterne, *A Sentimental Journey Through
France and Italy* (New York: The Modern Library,
n.d.), p. 702.

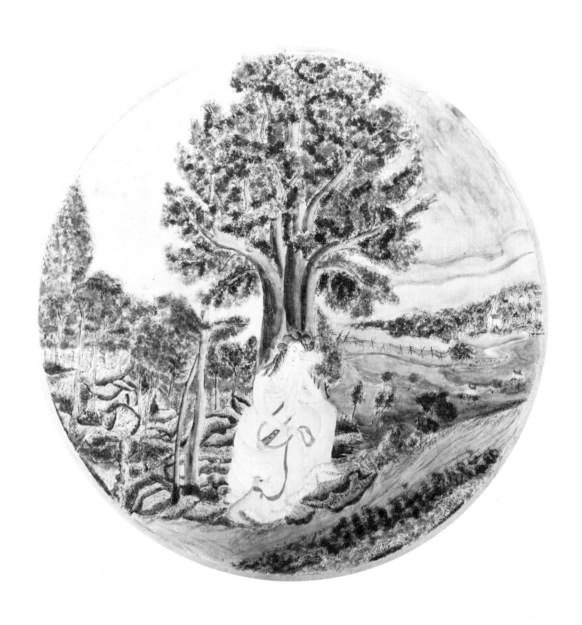

Catalogue no. 7

Joshua Johnson, attributed to
active 1796-1824 Baltimore, Maryland and vicinity

Self-Portrait ca. 1820
(Portrait of an American Negro and *Portrait of a Negro Man)*

oil on wood panel 48.2 x 34.6 cm
unsigned
A supposed second version of this painting
(Garbisch 48.51) is embossed, verso: *1824*

PROVENANCE:
Baltimore, Maryland; Garfield A. Berlinsky, Baltimore, Maryland; purchased from Berlinsky by Edgar William and Bernice Chrysler Garbisch, April 27, 1948 (Garbisch 48.52 also X604); Flint Institute of Arts, February 1981.
FIA 81.7

CONDITION:
Cleaned and in-painted by Sheldon Keck, 1948.

FRAME:
contemporary 7.6 x 3.8 cm
The face is gilded, the shallows darkened. The outside edge is painted a light brown.

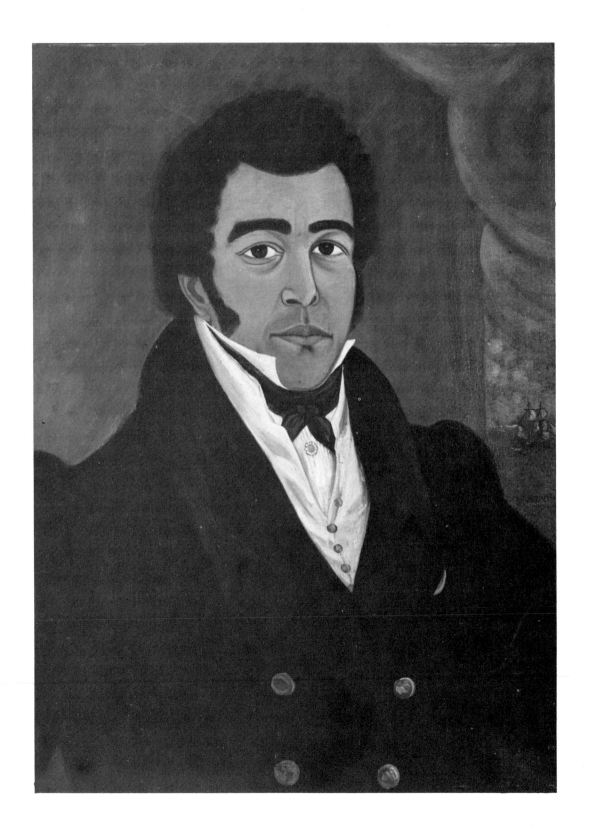

R. Swanson

Workhouse and Outbuildings, Newport, R.I.
ca. 1820
(The Factory Workhouse Scene and
View of a Mill Town)

oil on canvas 67.3 x 120.6 cm
unsigned

PROVENANCE:
Massachusetts; Florene Maine, Ridgefield, Con-
necticut; purchased from Maine by Edgar William
and Bernice Chrysler Garbisch, January 19, 1957
(Garbisch 57.6); Flint Institute of Arts, February
1981.
FIA 81.6

CONDITION:
Cleaned, relined and in-painted by Paul P. Kiehart,
1957.

FRAME:
reproduction 9.4 x 4.8 cm
The face is grained in brown tones. The outside edge
and liner are gilded.

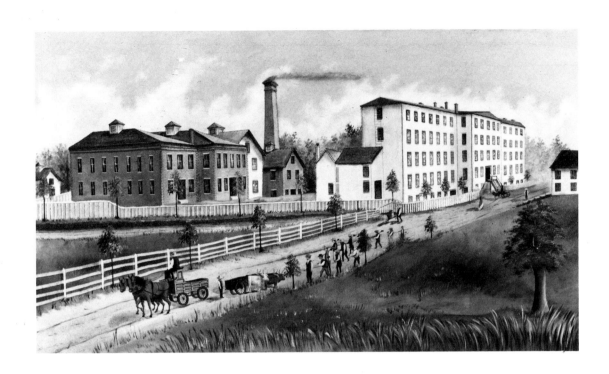

Catalogue no. 9

Unknown

Basket of Fruit with Cut Lemon ca. 1820

oil on wood panel 33.2 x 41.5 cm
unsigned

PROVENANCE:
New York; Victor D. Spark, New York, New York;
purchased from Spark by Edgar William and Bernice
Chrysler Garbisch, February 28, 1948 (Garbisch
48.23 also X1174); Flint Institute of Arts, December
1972.
FIA 72.72

CONDITION:
Cleaned and in-painted, a cross-grain batten re-
moved and the 8 mm thick panel retained mechan-
ically to a second panel by Paul P. Kiehart, 1959.

FRAME:
contemporary 6.7 x 4.7 cm
The face is gilded, the outside edge painted a sienna
tone.

EXHIBITIONS:
Frankenmuth (Michigan) Historical Museum,
American Naive, Aug. 7- Sept. 29, 1974; Battle
Creek Civic Art Center, *Heritage of American Art,*
Oct. 5-30, 1975, no. 15.

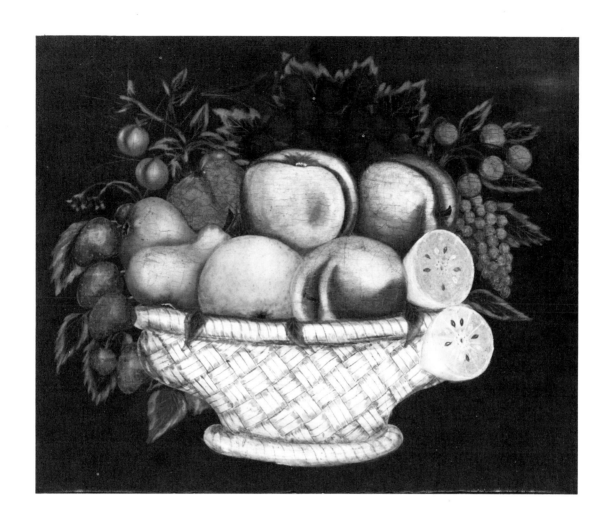

Catalogue no. 10

Unknown

Drummer Boy with Dog ca. 1820

oil on canvas 68.4 x 60.6 cm
unsigned

PROVENANCE:
Ohio; John's Antiques, Chicago, Illinois; purchased
from John's Antiques by Edgar William and Bernice
Chrysler Garbisch, January 26, 1959 (Garbisch
59.12 also X780); Flint Institute of Arts, December
1973.
FIA 73.90

CONDITION:
Cleaned, relined and in-painted by Paul P. Kiehart,
1964.

FRAME:
contemporary 5.2 x 3 cm
The face and outside edge are gilded.

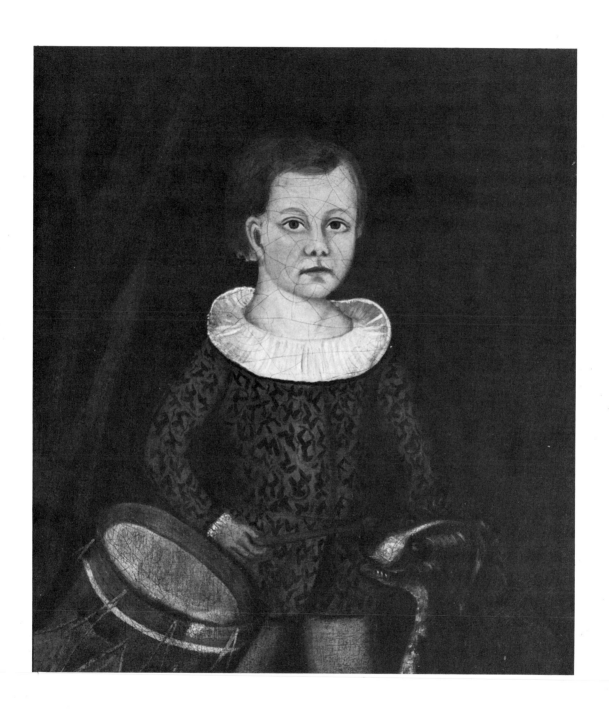

Catalogue no. 11

Almira Wheaton

Portrait of Levi Saben ca. 1824/25
(Lady in Straw Hat)
(The daughter of the artist)

watercolor on watermarked (J Whatman Turkey
Mill) paper 50.5 x 34.9 cm 38.7 x 30.2 cm
unsigned
inscribed in two hands, upper verso: *This was a
lesson in watercolor made about 1824 or 1825* and
No. 2 by Almira Wheaton mother of Levi Saben

PROVENANCE:
New Hampshire; Mary Andrews, Ashaway, Rhode
Island; purchased from Andrews by Edgar William
and Bernice Chrysler Garbisch, November 27, 1953
(Garbisch 53.93); Flint Institute of Arts, February
1981.
FIA 81.9

CONDITION:
Cleaned, repaired and lined with a thin oriental
paper by Christa M. Gaehde, in the mid-1960's.

FRAME:
original 4.9 x 2.9 cm
The entire surface is painted black.

Catalogue no. 12

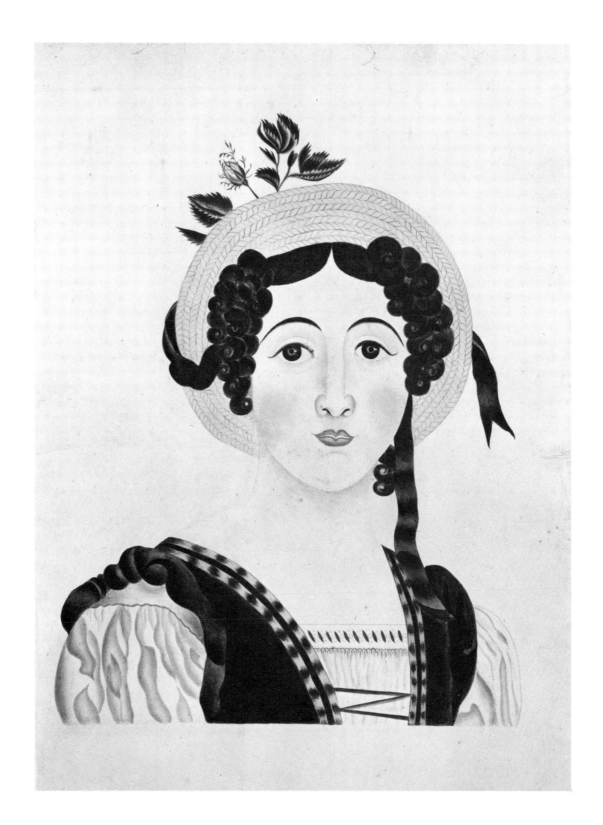

Sheldon Peck

born August 26, 1797 Cornwall, Vermont
died March 19, 1868 Babcock's Grove
(Lombard), Illinois

Mrs. Murry ca. 1825 (companion to 68.24)

oil on cradled wood panel 69.7 x 55.3 cm
unsigned

PROVENANCE:
Michigan; Robert Carlen, Philadelphia, Pennsyl-
vania; purchased from Carlen by Edgar William and
Bernice Chrysler Garbisch, December 5, 1955 (Gar-
bisch 55.69 also Gar 512 and X82??); Flint Insti-
tute of Arts, December 1968.
FIA 68.25

CONDITION:
Cleaned, in-painted, the panel reduced in thickness
and cradled with mahogany by Alberto Angeli,
1956.

FRAME:
contemporary 12.5 x 6 cm
The face is grained with sienna tones, the outside
edge and liner are gilded.

EXHIBITIONS:
Washington, D.C., National Gallery of Art, *Ameri-
can Primitive Paintings from the Collection of Edgar
William and Bernice Chrysler Garbisch Part II*, Mar. 16
- Apr. 28, 1957, p.38, repr.; Washington, D.C.,
National Gallery of Art, on loan, 1957-1968; New
York, Whitney Museum of American Art, *Sheldon
Peck*, Aug. 8 - Oct. 5, 1975, Williamsburg, Abby
Aldrich Rockefeller Folk Art Collection, Oct. 12 -
Dec. 1, 1975, Utica, Munson-Williams-Proctor In-
stitute, Dec. 14, 1975 - Feb. 8, 1976, Flint Institute
of Arts, Feb. 26 - Apr. 4, 1976, Springfield, Illinois
State Museum, Apr. 26 - May 30, 1976, no. 9, fig.
4.

REFERENCES:
Marianne E. Balazs, "Sheldon Peck", *The Magazine
Antiques*, vol. CVIII, no. 2, Aug. 1975, p.276, fig.
4.

Sheldon Peck

born August 26, 1797 Cornwall, Vermont
died March 19, 1868 Babcock's Grove
(Lombard), Illinois

Mr. Murry ca. 1825 (companion to 68.25)

oil on cradled wood panel 68.4 x 55.2 cm
unsigned

PROVENANCE:

Michigan; Robert Carlen, Philadelphia, Pennsylvania; purchased from Carlen by Edgar William and Bernice Chrysler Garbisch, December 5, 1955 (Garbisch 55.68 also Gar 511); Flint Institute of Arts, December 1968.
FIA 68.24

CONDITION:

Cleaned, in-painted, the panel reduced in thickness and cradled with mahogany by Alberto Angeli, 1956.

FRAME:

contemporary 12.5 x 6 cm
The face is grained with sienna tones, the outside edge and liner are gilded.

EXHIBITIONS:

Washington, D.C., National Gallery of Art, *American Primitive Paintings from the Collection of Edgar William and Bernice Chrysler Garbisch Part II*, Mar. 16 - Apr. 28, 1957, p.39, repr.; Washington, D.C., National Gallery of Art, on loan, 1957-1968; New York, Whitney Museum of American Art, *Sheldon Peck*, Aug. 8 - Oct. 5, 1975, Williamsburg, Abby Aldrich Rockefeller Folk Art Collection, Oct. 12 - Dec. 1, 1975, Utica, Munson-Williams-Proctor Institute, Dec. 14, 1975 - Feb. 8, 1976, Flint Institute of Arts, Feb. 26 - Apr. 4, 1976, Springfield, Illinois State Museum, Apr. 26 - May 30, 1976, no. 8, fig. 3.

REFERENCES:

Marianne E. Balazs, "Sheldon Peck", *The Magazine Antiques,* vol. CVIII, no. 2, Aug. 1975, p.276, fig. 3.

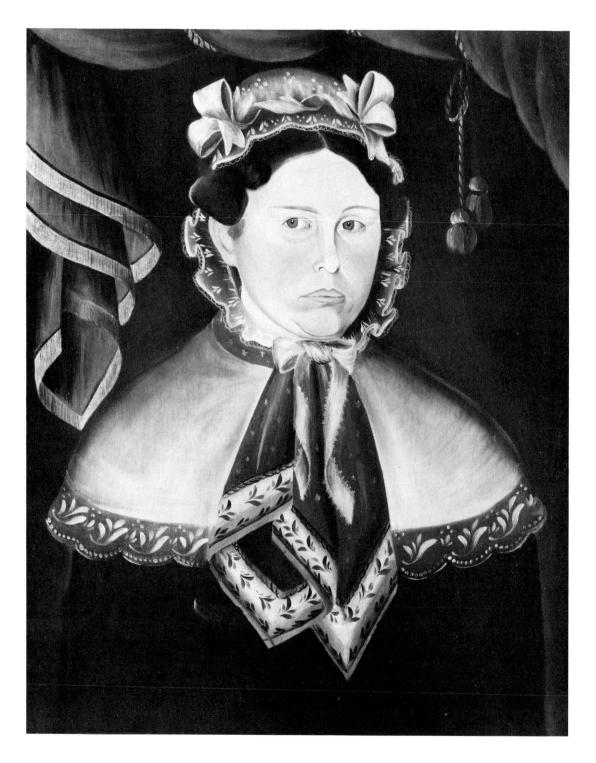

Catalogue no. 13

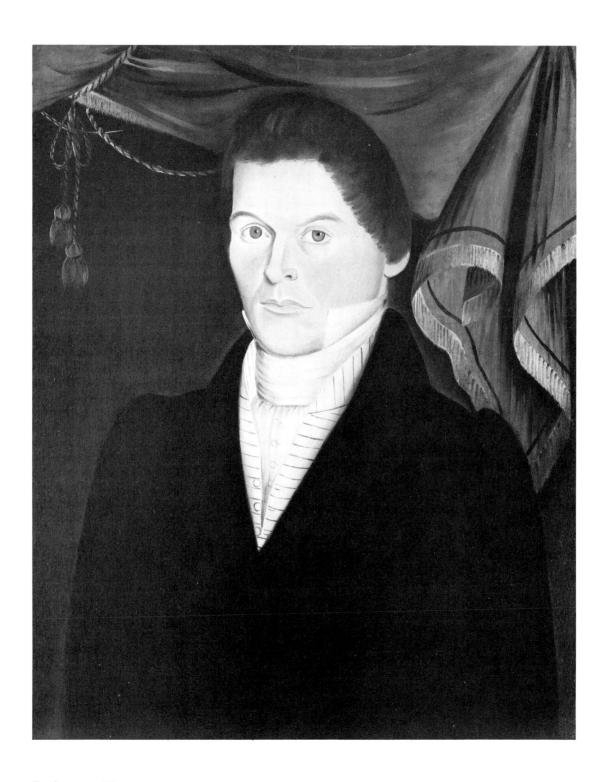

Catalogue no. 14

Unknown

Man Operating Steam Engine ca. 1825
(Man with Steam Engine)

oil on wood panel 30.3 x 22.3 cm
unsigned
embossed with oval mark, verso: *Winsor Newton*
LB or *L8 London*

PROVENANCE:
A. D. Bryant, Bristol, Maine; Robert L. Foster; pur-
chased from Foster by Edgar William and Bernice
Chrysler Garbisch, January 27, 1965 (Garbisch
65.1); Flint Institute of Arts, February 1981.
FIA 81.8

CONDITION:
Cleaned, in-painted and retained mechanically to a
second panel by Paul P. Kiehart, 1980.

FRAME:
original 7.3 x 3.2 cm
The face is veneered in mahogany, its inside and
outside edges are of cherry.

Catalogue no. 15

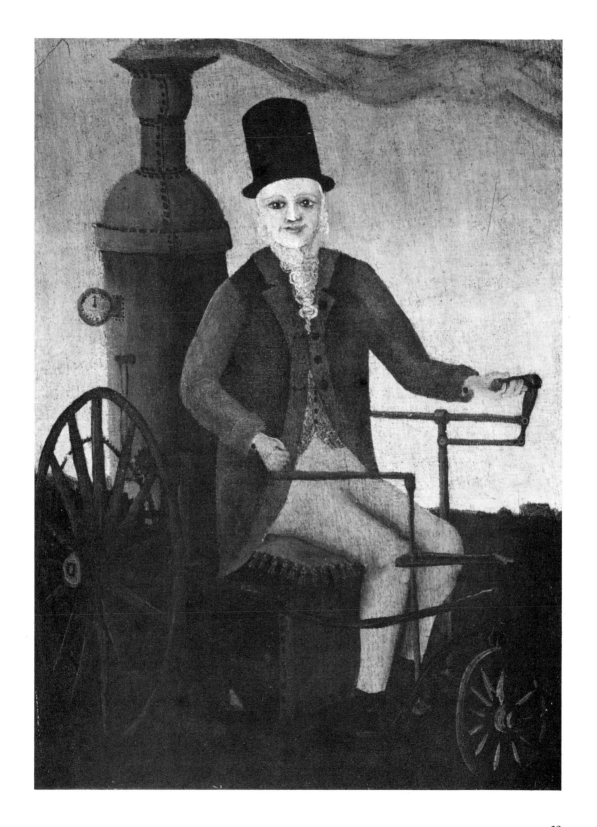

Unknown

Portrait of a Woman ca. 1825
(companion to 73.88)
(Woman with White Lace Cap with Blue Ribbons)

oil on canvas 63.5 x 55.2 cm
unsigned

PROVENANCE:
New York; David Hollander, New York, New York; purchased from Hollander by Edgar William and Bernice Chrysler Garbisch, March 27, 1958 (Gargisch 58.21); Flint Institute of Arts, December 1973. FIA 73.89

CONDITION:
Cleaned, relined, adhered to a honeycomb panel and in-painted by Paul P. Kiehart, 1969.

FRAME:
reproduction 7 x 4.5 cm
The face and outside edge are painted black.

Unknown

Portrait of a Man ca. 1825
(companion to 73.89)
*(Man with Brown Hair and Sideburns Wearing
White Stock)*

oil on canvas 63.7 x 55.4 cm
unsigned

PROVENANCE:
New York; David Hollander, New York, New York;
purchased from Hollander by Edgar William and
Bernice Chrysler Garbisch, March 27, 1958 (Gar-
bisch 58.20); Flint Institute of Arts, December 1973.
FIA 73.88

CONDITION:
Cleaned, relined, adhered to a honeycomb panel and
in-painted by Paul P. Kiehart, 1969.

FRAME:
reproduction 6.9 x 4.2 cm
The face and outside edge are painted black.

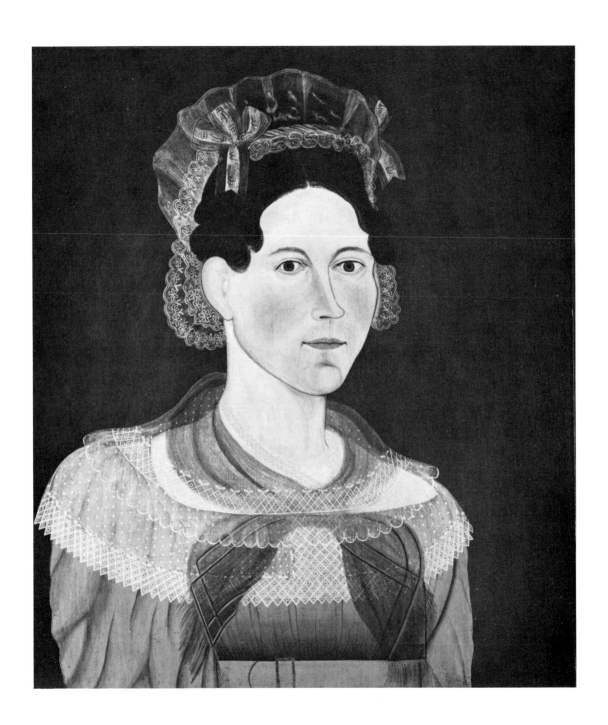

Catalogue no. 16

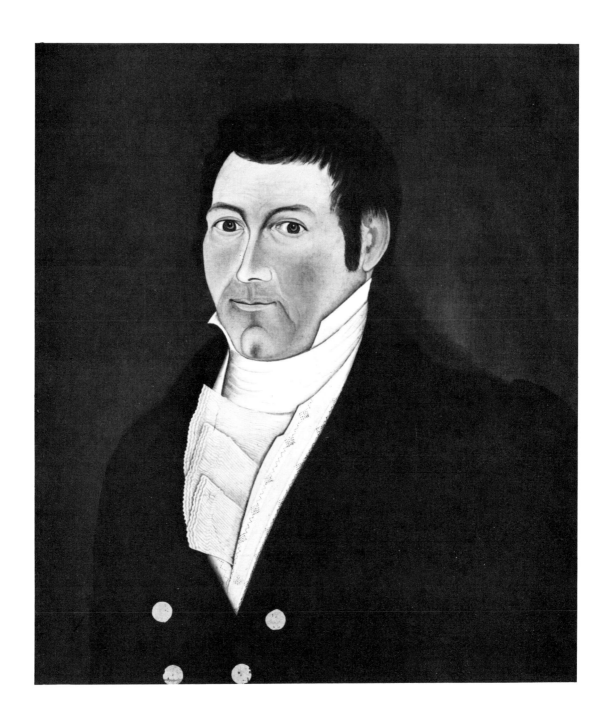

Catalogue no. 17

Erastus Salisbury Field, attributed to
born May 19, 1805 Leverett, Massachusetts
died June 28, 1900 Plumtrees (Sunderland),
Massachusetts

Portrait of a Lady in Yellow Painted Chair 1829

oil on canvas 68.7 x 56.2 cm
unsigned
inscribed, verso of original canvas:
Painted June 1829

PROVENANCE:
Connecticut; Antiques, Inc.; purchased from An-
tiques, Inc. by Edgar William and Bernice Chrysler
Garbisch, January 29, 1959 (Garbisch 59.22 also
X1226); Flint Institute of Arts, December 1973.
FIA 73.91

CONDITION:
Cleaned, relined and in-painted by Paul P. Kiehart,
1962.

FRAME:
contemporary 7.5 x 5.7 cm
The face is gilded, the outside edge painted a greyed
ochre tone.

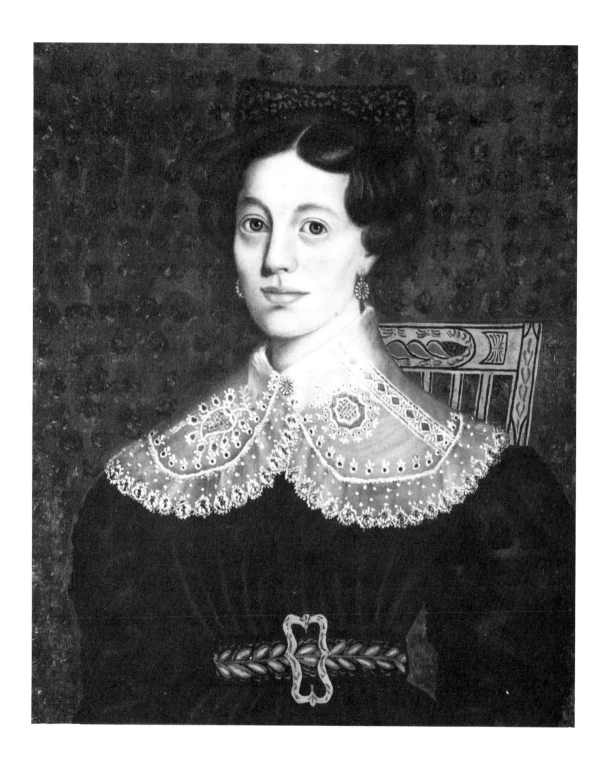

Catalogue no. 18

Unknown (Sophnia Camp?)

Flora the Goddess of Flowers ca. 1830
(Wallingford Union Academy, Wallingford,
Connecticut, incorporated 1812)

Watercolor on watermarked (illegible) paper
40.5 x 50.4 cm 40.3 x 41.2 cm
unsigned
inscribed by the artist, recto: *Flora the Goddess of
Flowers Wallingford Union Academy
Sophnia Camp*

PROVENANCE:
Massachusetts; Clifton Blake; purchased from Blake
by Edgar William and Bernice Chrysler Garbisch,
March 9, 1949 (Garbisch 49.95); Flint Institute of
Arts, December 1972.
FIA 72.76

CONDITION:
Cleaned and lined with a thin oriental paper by
Christa M. Gaehde, 1962.

FRAME:
original 7.9 x 2.4 cm
The face is silver gilt, the outside edge painted a
sienna tone at a later date.

EXHIBITIONS:
Frankenmuth (Michigan) Historical Museum,
American Naive, Aug. 7 - Sept. 29, 1974; Battle
Creek Civic Art Center, *Heritage of American Art*,
Oct. 5-30, 1975, no. 18.

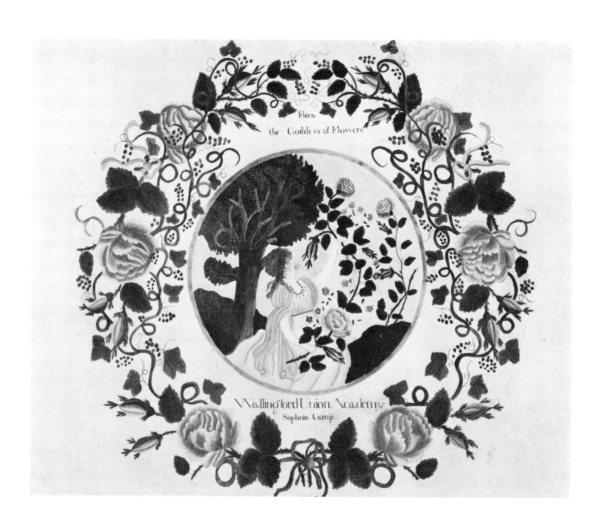

Catalogue no. 19

Unknown

Woman and Boy in Landscape ca. 1830

watercolor on paper 24.4 x 35 cm
24 x 34.6 cm
unsigned

PROVENANCE:
New York; purchased from an unknown source at an unknown date by Edgar William and Bernice Chrysler Garbisch, (Garbisch X.13 also Gar XB13 and X755); Flint Institute of Arts, February 1981.
FIA 81.12

CONDITION:
Cleaned and lined with a thin oriental paper by Christa M. Gaehde.

FRAME:
contemporary 6.4 x 2.2 cm
The two-part face is of mahogany veneer, the outside edge painted a sienna tone.

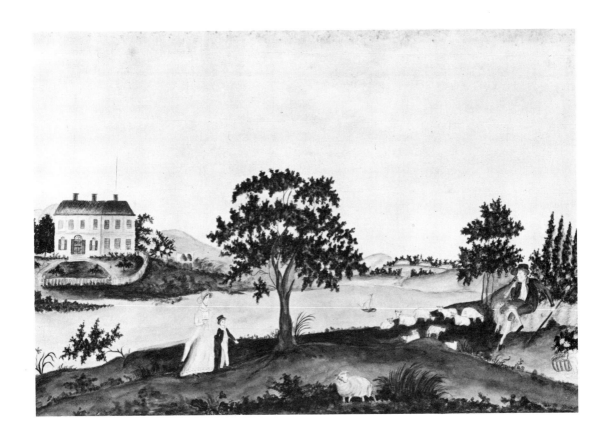

Catalogue no. 20

Noah North

born June 27, 1809 Alexander, New York
died June 15, 1880 Attica, New York

Major J. R. Jackman ca. 1833-34
(companion to 68.22)
(James R. Jackman, born April 7, 1793, Vershire,
Vermont, died November 23, 1864, Alexander,
New York)

oil on wood panel 70.6 x 59 cm
unsigned
inscribed in crayon, upper left verso: *Major
Jackman, husband of Gracie*

PROVENANCE:
Western New York; B. H. Leffingwell, Rochester,
New York; purchased from Leffingwell by Edgar
William and Bernice Chrysler Garbisch, October 22,
1952 (Garbisch 52.82 also Gar 483 and X48.216);
Flint Institute of Arts, December 1968.
FIA 68.21

CONDITION:
Cleaned and in-painted and the verso coated with
mirocrystaline wax by Alberto Angeli, 1953.

FRAME:
contemporary 10 x 5 cm
The face and outside edge are grained with sienna
tones, the liner is painted gold.

EXHIBITIONS:
Washington, D.C., National Gallery of Art, on
loan, 1957-1968.

REFERENCES:
Nancy C. Muller and Jacquelyn Oak, "Noah North:
1809-1880", *The Magazine Antiques,* vol. CXII, no.
5, Nov. 1977, pp.940, 942.

Noah North
born June 27, 1809 Alexander, New York
died June 15, 1880 Attica, New York

Gracie Beardsley Jefferson Jackman and her Daughter
ca. 1833-34 (companion to 68.21)
(born Hungersfield, New York, April 28, 1803,
died Alexander, New York, April 14, 1887,
daughter Louise born ca. 1832 or Sarah L. born
1833)

oil on wood panel 70.9 x 59.5 cm
unsigned
inscribed in crayon, upper left verso: *Gracie
Beardsley Jefferson wife of J. R. Jackman 1835-6*

PROVENANCE:
Western New York; B. H. Leffingwell, Rochester,
New York; purchased from Leffingwell by Edgar
William and Bernice Chrysler Garbisch, October 22,
1952 (Garbisch 52.83 also Gar 484 and X48.217);
Flint Institute of Arts, December 1968.
FIA 68.22

CONDITION:
Cleaned and in-painted and the verso coated with
microcrystaline wax by Alberto Angeli, 1953.

FRAME:
contemporary 10 x 5 cm
The face and outside edge are grained with sienna
tones, the liner is painted gold.

EXHIBITIONS:
Washington, D.C., National Gallery of Art, *American Primitive Paintings from the Collection of Edgar
William and Bernice Chrysler Garbisch Part II,* Mar. 16
- Apr. 28, 1957, p.45, repr.; Washington, D.C.,
National Gallery of Art, on loan, 1957 - 1968; New
York, Whitney Museum of American Art, *American
Folk Painters of Three Centuries,* Feb 25 - May 13,
1980, p.132, color repr.

REFERENCES:
Nancy C. Muller and Jacquelyn Oak, "Noah North:
1809 - 1880", *The Magazine Antiques,* vol. CXII, no.
5, Nov. 1977, pp.940, 942, fig. 2; New York, Whit-
ney Museum of American Art, *American Folk Painters of Three Centuries,* Feb. 25 - May 13, 1980,
p.129, color repr., p.132.

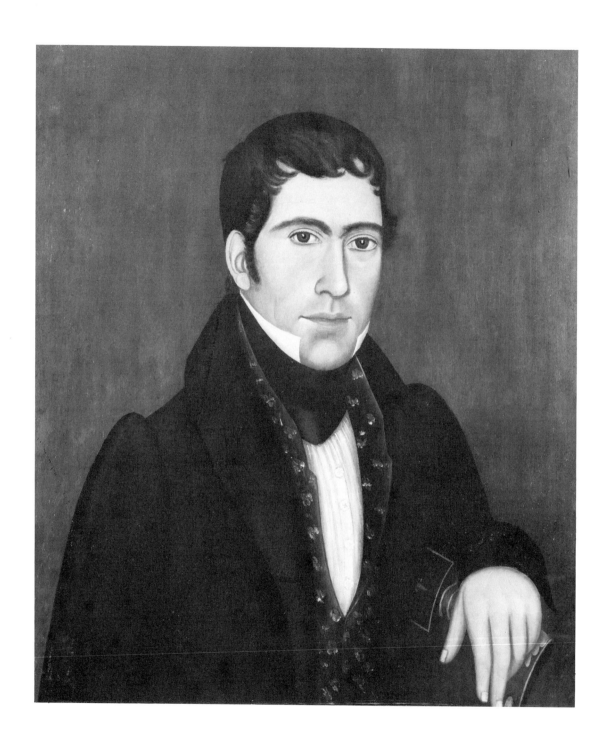

Catalogue no. 21

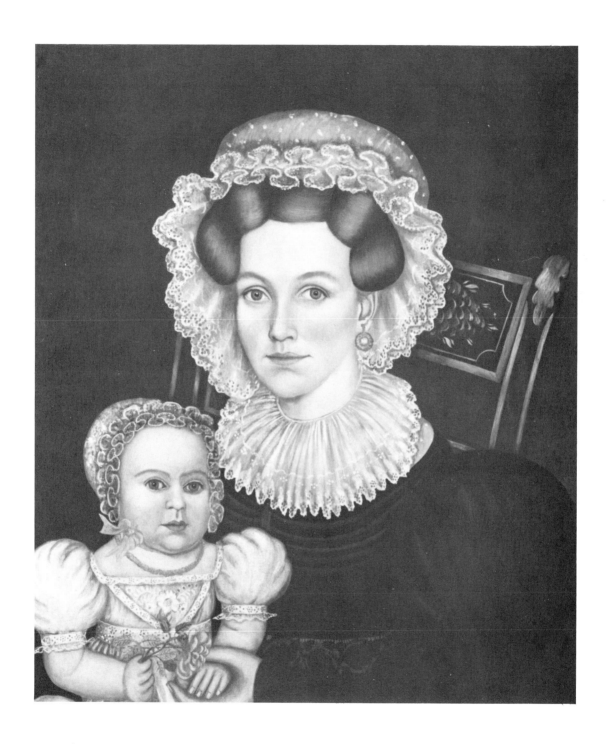

Catalogue no. 22

Joseph H. Davis
active 1832-1838 Maine and New Hampshire
(living Newfield, Maine?)

Isaac T. Demeritt 1835

watercolor on paper 29.2 x 20.6 cm
26.3 x 19.2 cm
unsigned dated, lower right: *1835*
inscribed by the artist, recto: *Isaac T. Demeritt.*
Painted at the Age of 24, 1835

PROVENANCE:
New Hampshire; Mrs. Leslie E. Norton; purchased
from Norton by Edgar William and Bernice Chrysler
Garbisch, January 24, 1949 (Garbisch 49.24); Flint
Institute of Arts, December 1972.
FIA 72.75

CONDITION:
Cleaned and lined with a thin oriental paper by
Christa M. Gaehde, 1964.

FRAME:
original 3.5 x 1.7 cm
The face and outside edge are painted black.

EXHIBITIONS:
Frankenmuth (Michigan) Historical Museum,
American Naive, Aug. 7 - Sept. 29, 1974; Battle
Creek Civic Art Center, *Heritage of American Art*,
Oct. 5-30, 1975, no. 20.

Catalogue no. 23

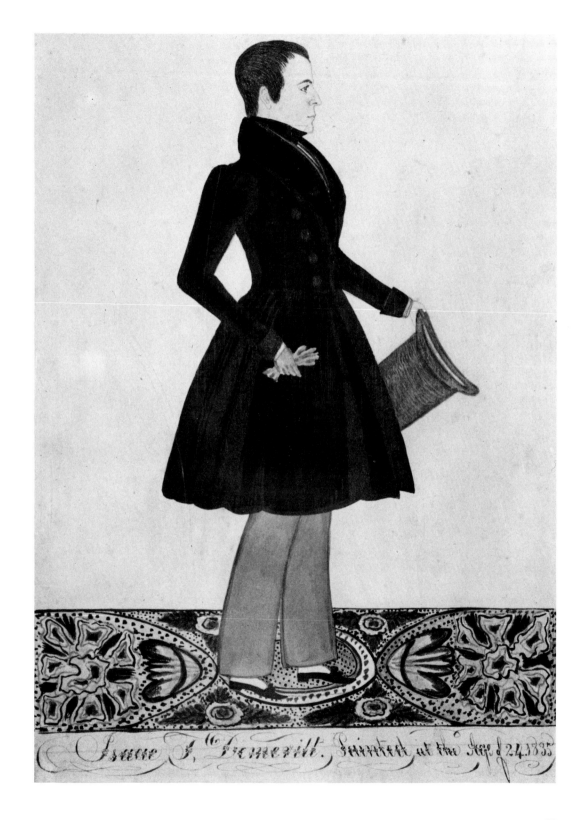

Isaac J. Somerill. Painted at the Age of 24. 1835

William Matthew Prior, attributed to
born May 16, 1806 Bath, Maine
died January 1873 Boston, Massachusetts

Baby in Pink and White ca. 1840
(Little Janey in Pink and White Dress)

oil on canvas 61.2 x 50.4 cm
unsigned

PROVENANCE:
Duncan Candler, Canaan, Connecticut; Thomas D.
and Constance R. Williams, Litchfield, Connec-
ticut; purchased from Williams by Edgar William and
Bernice Chrysler Garbisch, December 20, 1949
(Garbisch 49.441 also Gar 63 and X438); Flint In-
stitute of Arts, December 1968.
FIA 68.19

CONDITION:
Cleaned, relined and in-painted by Alberto Angeli,
1950.

FRAME:
original 8.8 x 2.4 cm
The face and outside edge are grained with sienna
tones.

EXHIBITIONS:
Washington, D.C., National Gallery of Art, *Ameri-
can Primitive Paintings from the Collection of Edgar
William and Bernice Chrysler Garbisch Part II,* Mar. 16
- Apr. 28, 1957, p.73, repr.; Washington, D.C.,
National Gallery of Art, on loan, 1957-1968; Frank-
enmuth (Michigan) Historical Museum, *American
Naive,* Aug. 7 - Sept. 29, 1974.

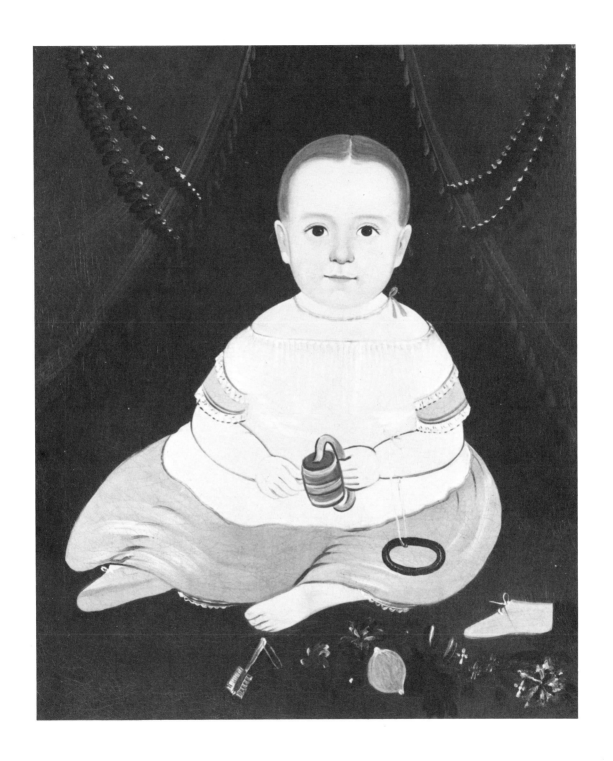

Catalogue no. 24

Unknown

Baby Reclining ca. 1840
(Nonchalance, little baby girl in blue dress with red booties)

oil on canvas 69 x 84.6 cm
unsigned

PROVENANCE:
Massachusetts; Vose Galleries, Boston, Massachusetts; purchased from Vose Galleries by Edgar William and Bernice Chrysler Garbisch, February 18, 1954 (Garbisch 54.11 also Gar 424); Flint Institute of Arts, December 1968.
FIA 68.23

CONDITION:
Cleaned, relined and in-painted by Louis Pomerantz, 1954.

.FRAME:
original 9 x 6.6 cm
The face is gilded, the outside edge painted an ochre tone.

EXHIBITIONS:
Washington, D.C., National Gallery of Art, *American Primitive Paintings from the Collection of Edgar William and Bernice Chrysler Garbisch Part II,* Mar. 16 - Apr. 28, 1957, p.76, repr.; Washington, D.C., National Gallery of Art, on loan, 1957-1968.

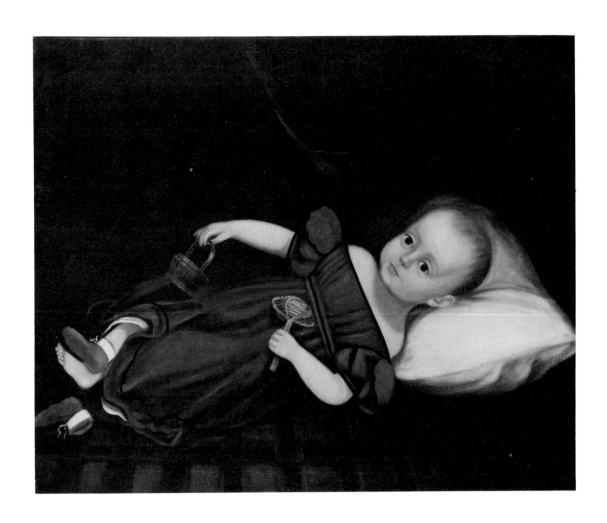

Catalogue no. 25

Unknown

The Crucifixion ca. 1840
(Jesus on the Cross)

oil on canvas 106.8 x 76.1 cm
unsigned

PROVENANCE:
Pennsylvania; Charlotte and Edgar H. Sittig, Shaw-
nee, Pennsylvania; purchased from Sittig by Edgar
William and Bernice Chrysler Garbisch, October 31,
1951 (Garbisch 51.145 also Gar 437); Flint Institute
of Arts, February 1981.
FIA 81.5

CONDITION:
Cleaned, relined and in-painted by Alberto Angeli,
1954.

FRAME:
reproduction 9.4 x 2.6 cm
The face and outside edge are stained rosewood ven-
eer, the liner gilded.

EXHIBITIONS:
Washington, D.C., National Gallery of Art, on
loan, 1959-1980.

Catalogue no. 26

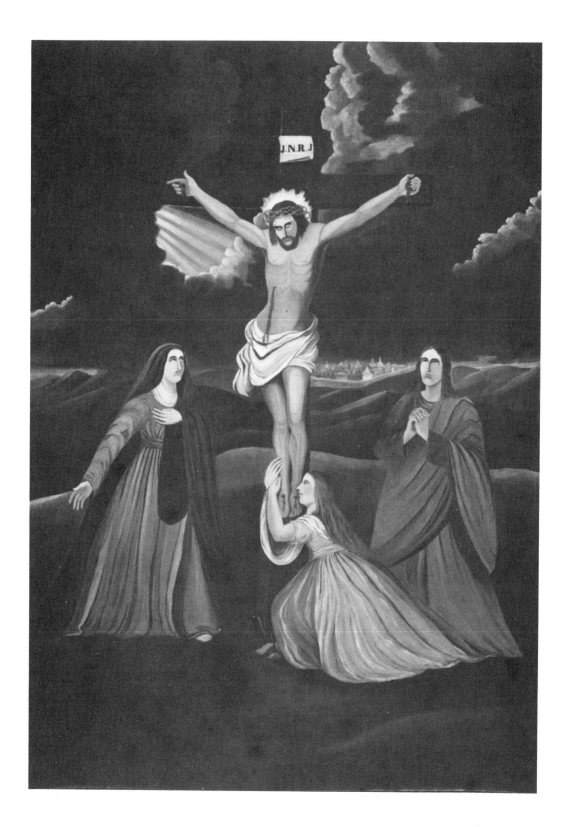

Unknown

Hannah M. Gregory ca. 1840
(Little Girl in Landscape Holding Rose)

oil on canvas 31.5 x 38 cm
unsigned

PROVENANCE:
Massachusetts; Teina Baumstone, New York, New York; purchased from Baumstone by Edgar William and Bernice Chrysler Garbisch, February 7, 1957 (Garbisch 57.14); Flint Institute of Arts, December 1973.
FIA 73.86

CONDITION:
Cleaned, relined and in-painted by Paul P. Kiehart, 1960.

FRAME:
original 4 x 3.1 cm
The face is gilded, the outside edge painted an ochre tone.

EXHIBITIONS:
Frankenmuth (Michigan) Historical Museum, *American Naive,* Aug. 5 - Sept. 29, 1974.

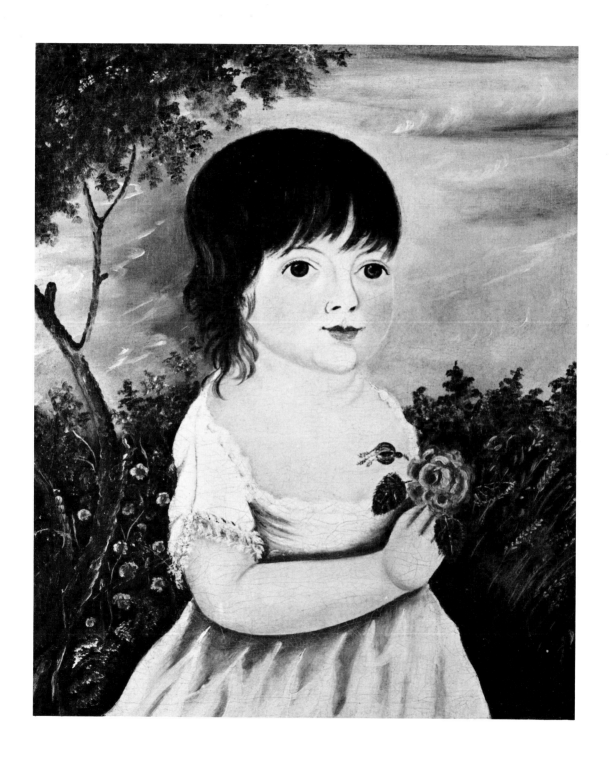

Catalogue no. 27

Unknown

Portrait of Child with Doll　ca. 1840

oil on canvas　76.3 x 63.4 cm
unsigned

PROVENANCE:
Doll & Richards, Inc., Boston, Massachusetts; Mary
Sampson, Boston, Massachusetts; James and Evelyn
Wilcoxen, Henniker, New Hampshire; purchased
from Wilcoxen by Edgar William and Bernice
Chrysler Garbisch, January 16, 1957 (Garbisch
57.10); Flint Institute of Arts, December 1973.
FIA 73.85

CONDITION:
Cleaned, relined and in-painted by Paul P. Kiehart,
1957.

FRAME:
original　8 x 5.3 cm
The face is gilded, the outside edge painted an ochre
tone.

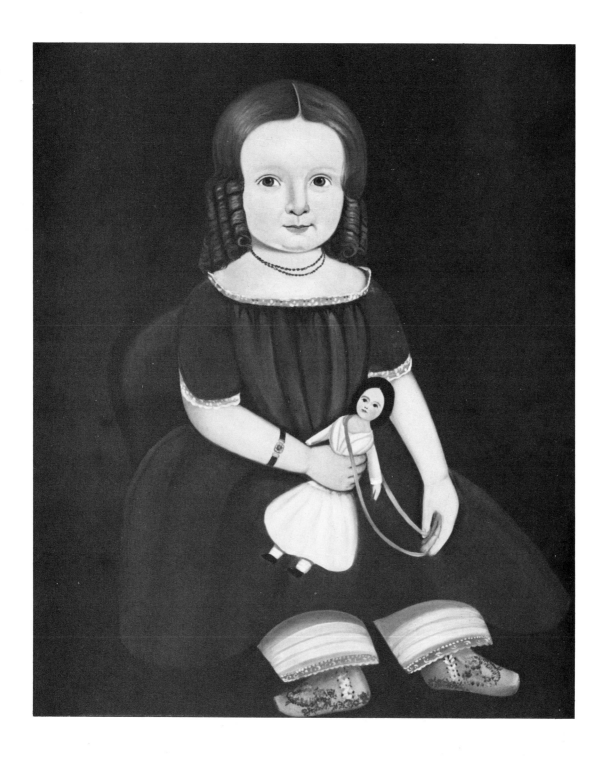

Catalogue no. 28

Unknown

Portrait of Man with Colorful Vest and White
Up-turned Collar ca. 1840
(companion to 81.2)
(Portrait of a Man)

oil on canvas 65 x 54.8 cm
unsigned

PROVENANCE:
New York; Albert Duveen, New York, New York;
purchased from Duveen by Edgar William and Ber-
nice Chrysler Garbisch, June 10, 1948 (Garbisch
48.79); Flint Institute of Arts, February 1981.
FIA 81.1

CONDITION:
Cleaned, relined, adhered to a honeycomb panel and
in-painted by Paul P. Kiehart, 1980.

FRAME:
original 10.8 x 7.8 cm
The face is grained in tones of sienna, the ribbing at
the inner and outer edge painted gold. The outside
edge is painted an umber tone. The face bears leaf
designs painted in gold at the four corners and birds
at the centers of the four sides.

Unknown

*Portrait of Woman Wearing Gold Hanging Earring on
Left Ear and Gold Chain Necklace*
ca. 1840 (companion to 81.1)
(Portrait of a Woman)

oil on canvas 65.5 x 55.4 cm
unsigned

PROVENANCE:
New York; Albert Duveen, New York, New York;
purchased from Duveen by Edgar William and Bernice Chrysler Garbisch, June 10, 1948 (Garbisch
48.80); Flint Institute of Arts, February 1981.
FIA 81.2

CONDITION:
Cleaned, relined, adhered to a honeycomb panel and
in-painted by Paul P. Kiehart, 1980.

FRAME:
original 10.8 x 7.8 cm
The face is grained in tones of sienna, the ribbing at
the inner and outer edge painted gold. The outside
edge is painted an umber tone. The face bears leaf
designs painted in gold at the four corners and birds
at the centers of the four sides.

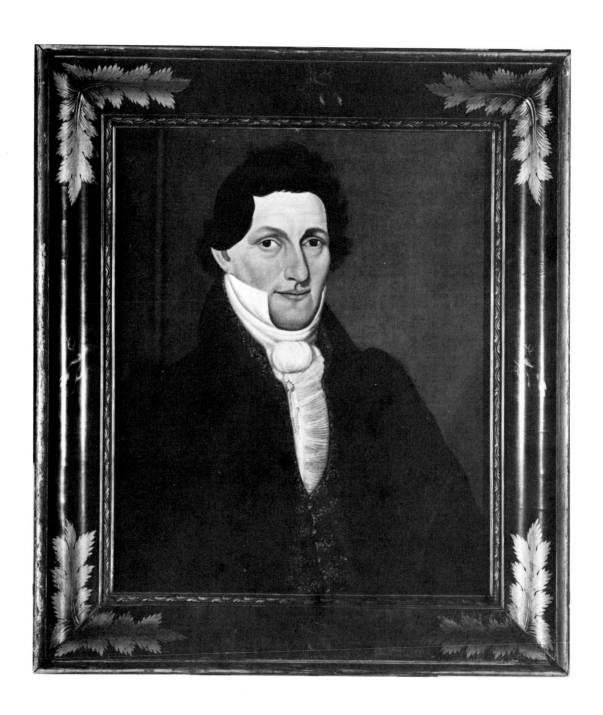

Catalogue no. 29

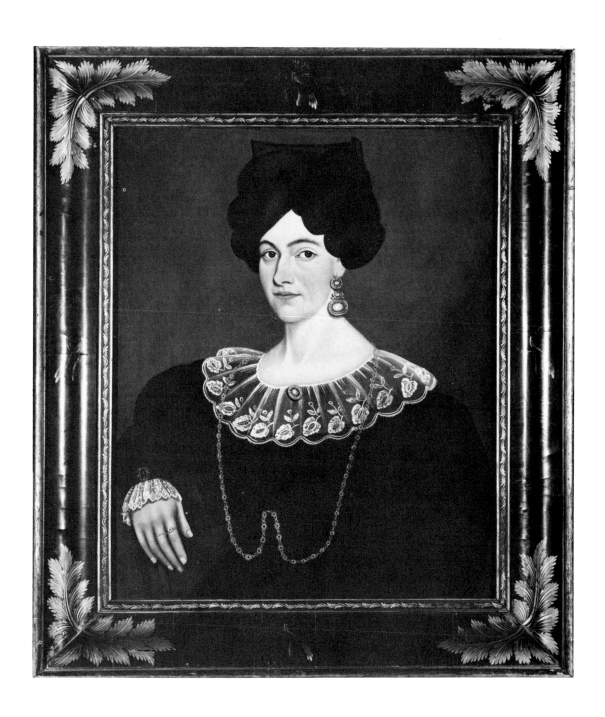

Catalogue no. 30

Unknown

Spaniel ca. 1840

oil on canvas 74.6 x 113.8 cm
unsigned

PROVENANCE:
New York; John's Antiques, Chicago, Illinois; purchased from John's Antiques by Edgar William and Bernice Chrysler Garbisch, January 16, 1958 (Garbisch 58.3); Flint Institute of Arts, December 1973. FIA 73.87

CONDITION:
Cleaned, relined and in-painted by Paul P. Kiehart, 1958.

FRAME:
original 7.7 x 7.2 cm
(7.7 x 5.7 cm orig.)
The face is gilded, the outside edge painted an ochre tone. The depth of the molding was increased at a later date.

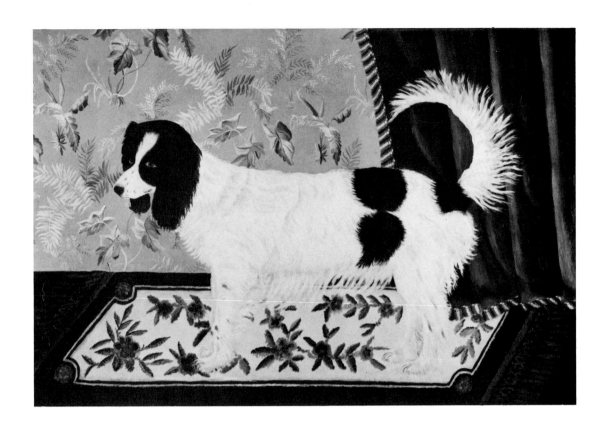

Catalogue no. 31

Unknown (T.R.?)

Humming Bird, Red Bird, Baltimore Bird, Robbin,
Flicker, Blue Bird 1842
(Six Birds on Tree Branches, Spring 1842 and Birds)

oil on wood panel 31 x 25.5 cm
unsigned
inscribed, center verso: *To Martha Jane*
Humming Bird, Red Bird, Baltimore Bird, Robbin,
Flicker, Blue Bird Spring 1842 T.R.

PROVENANCE:
Pennsylvania; Charlotte and Edgar H. Sittig, Shaw-
nee, Pennsylvania; purchased from Sittig by Edgar
William and Bernice Chrysler Garbisch, January 29,
1960 (Garbisch 60.4); Flint Institute of Arts, Febru-
ary 1981.
FIA 81.3

CONDITION:
Cleaned and in-painted by Paul P. Kiehart, 1965.

FRAME:
original 5.4 x 1.8 cm
Oak painted black.

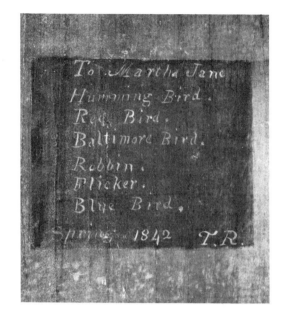

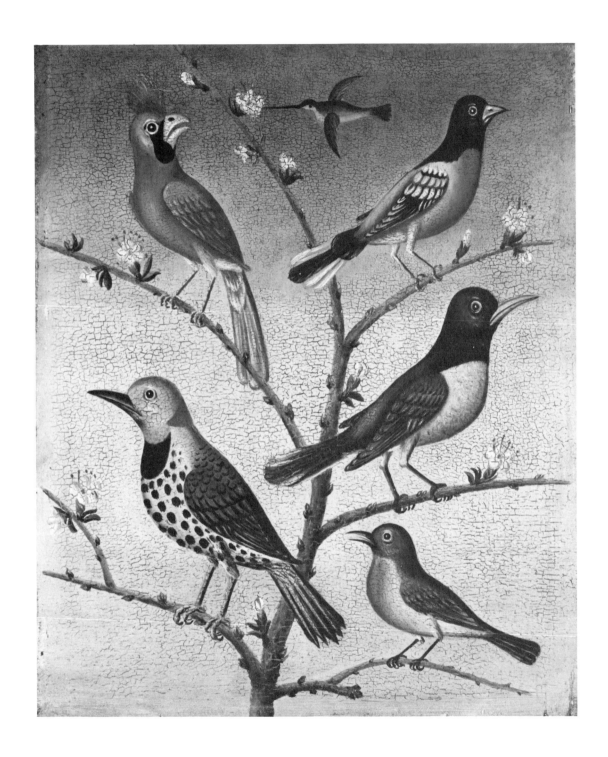

Catalogue no. 32

Unknown

George Washington 1849

oil on mattress ticking 86.5 x 74.2 cm
unsigned dated on the plans and sitter holds: *1849*
inscribed above date: *His First P*

PROVENANCE:
New York; Victor D. Spark, New York, New York;
purchased from Spark by Edgar William and Bernice
Chrysler Garbisch, June 24, 1947 (Garbisch 47.35
also Gar 116); Flint Institute of Arts, February 1981.
FIA 81.4

CONDITION:
Prior to its acquisition by the Garbisches, the paint-
ing was cleaned, relined and in-painted.

FRAME:
original 6.3 x 3.1 cm
The face is gilded, the outside edge painted brown.

EXHIBITIONS:
Milwaukee Art Museum, *American Primitive Paint-
ings, 1750-1950,* Feb. 24 - March 25, 1951; Wash-
ington, D.C., National Gallery of Art, on loan,
1953-1980.

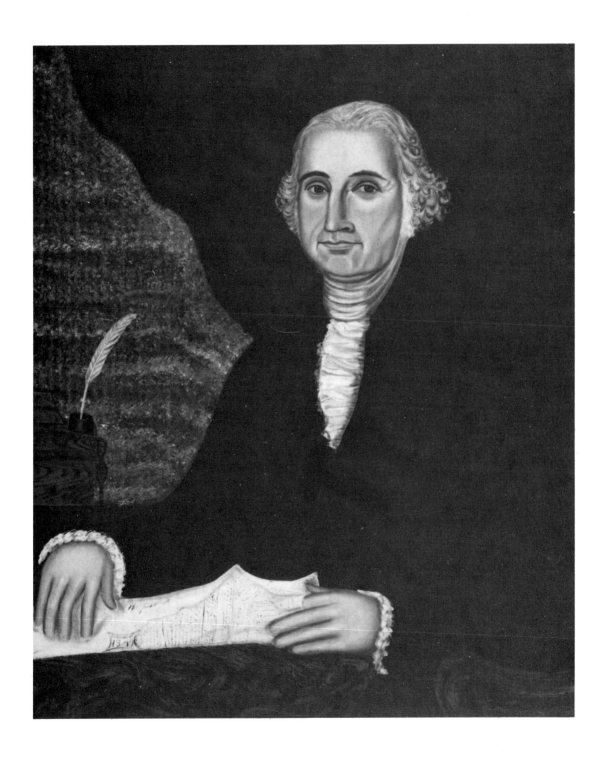

Catalogue no. 33

Thomas Chambers
born 1807/8 London, England
by 1834 New York, New York
living 1866 New York, New York

Old Sleepy Hollow Church ca. 1850
(Hudson River Valley, near Tarrytown, New
York?)

oil on canvas 46.3 x 61.6 cm
unsigned

PROVENANCE:
Hudson River Valley, New York; Louis Lyons, New
York, New York; purchased from Lyons by Edgar
William and Bernice Chrysler Garbisch, March 11,
1949 (Garbisch 49.104 also Gar 253 and X115);
Flint Institute of Arts, December 1968.
FIA 68.18

CONDITION:
Cleaned, relined and in-painted by Alberto Angeli,
1950.

FRAME:
original 6 x 3 cm
The face is silver gilt, the outside edge painted a
sienna tone.

EXHIBITIONS:
Washington, D.C., Smithsonian Institution office of
Traveling Exhibitions, *American Primitive Paintings,*
Lucerne, Kunstmuseum, June 19 - Oct. 3, 1954,
Vienna, Technisches Museum für Industrie und
Gewerbe, Oct. 27 - Nov. 20, 1954, Museum für
Kunst und Kulturgeschichte der Stadt Dortmund,
Dec. 10, 1954 - Jan. 3, 1955, Munich, American
House, Jan. 8 - Feb. 6, 1955, Stockholm, Liljevalchs
Konsthall, Feb. 20 - Mar. 15, 1955, Olso,
Kunstnernes Hus, Mar. 26 - Apr. 17, 1955, Man-
chester, City Art Gallery, May 4-30, 1955, London,
Whitechapel Art Gallery, June 3 - July 3, 1955,
Trier, Rheinsches Landesmuseum Trier, Aug. 7 -
Sept. 5, 1955, no. 48; Washington, D.C., National
Gallery of Art, *American Primitive Paintings from the
Collection of Edgar William and Bernice Chrysler Gar-
bisch Part II,* Mar. 16 - Apr. 28, 1957, p.60, repr.;
Washington, D.C., Smithsonian Institution office of
Traveling Exhibitions, *American Folk Art,* Brussels

Universal and International Exposition, Apr. 17 -
Oct. 18, 1958, no. 55; Washington, D.C., National
Gallery of Art, on loan, 1959-1968.

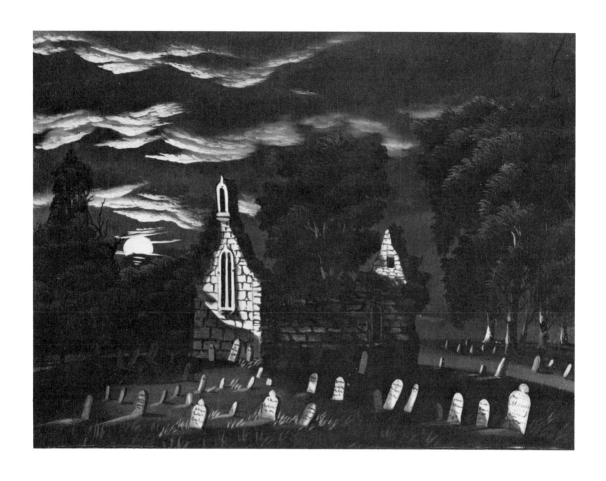

Catalogue no. 34

Thomas Chambers
born 1807/8 London, England
by 1834 New York, New York
living 1866 New York, New York

Village in Foothills ca. 1850

oil on canvas 55.6 x 76 cm
unsigned

PROVENANCE:
New York; Chicago, Illinois; John Bihler and Henry
Coger, Ashley Falls, Massachusetts; purchased from
Bihler and Coger by Edgar William and Bernice
Chrysler Garbisch, April 7, 1960 (Garbisch 60.27
also X65.7); Flint Institute of Arts, December 1972.
FIA 72.73

CONDITION:
Cleaned, relined, adhered to a honeycomb panel and
in-painted by Paul P. Kiehart, 1969.

FRAME:
contemporary 6.5 x 4 cm
The face and outside edge are painted black, the
liner painted a bronze tone.

EXHIBITIONS:
Frankenmuth (Michigan) Historical Museum,
American Naive, Aug. 7 - Sept. 29, 1974; Battle
Creek Civic Art Center, *Heritage of American Art,*
Oct. 5-30, 1975, no. 27.

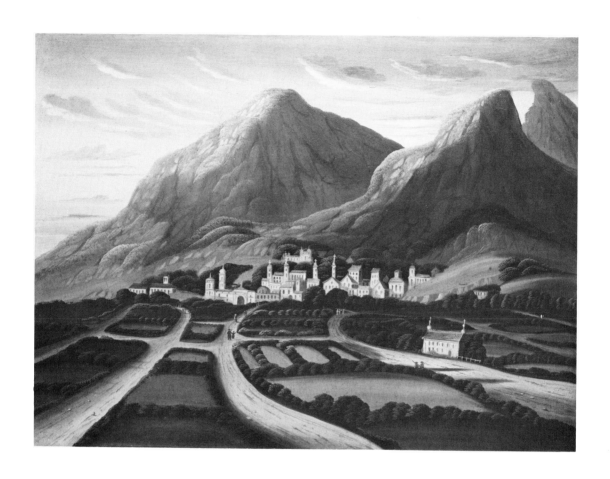

Catalogue no. 35

Erastus Salisbury Field

born May 19, 1805 Leverett, Massachusetts
died June 28, 1900 Plumtrees (Sunderland),
Massachusetts

The Taj Mahal ca. 1850
(Two additional versions of this composition are in
the collection of the Museum of Fine Arts,
Springfield)

oil on canvas 60.3 x 85.8 cm
unsigned

PROVENANCE:
Massachusetts; Robert Schuyler Tompkins, Mon-
tague, Massachusetts; purchased from Tompkins by
Edgar William and Bernice Chrysler Garbisch, Feb-
ruary 20, 1950 (Garbisch 50.15 also Gar 481); Flint
Institute of Arts, December 1968.
FIA 68.20

CONDITION:
Cleaned, relined and in-painted by Alberto Angeli,
1950.

FRAME:
contemporary
6.7 x 5.5 cm (6.7 x 4.5 cm orig.)
The face and outside edge are grained with sienna
tones. The depth of the molding was increased at a
later date.

EXHIBITIONS:
Washington, D.C., National Gallery of Art, *Ameri-
can Primitive Paintings from the Collection of Edgar
William and Bernice Chrysler Garbisch Part II*, Mar. 16
- Apr. 28, 1957, p.108, repr.; Washington, D.C.,
Smithsonian Institution office of Traveling Exhi-
bitions, *American Primitive Paintings from the Collec-
tion of Edgar William and Bernice Chrysler Garbisch*,
Springfield (Missouri) Art Museum, Oct. 5-29,
1958; Washington, D.C., National Gallery of Art,
on loan, 1959-1968; Frankenmuth (Michigan) His-
torical Museum, *American Naive*, Aug. 7 - Sept. 29,
1974.

REFERENCES:
Agnes M. Dods and Reginald French, "Erastus Salis-
bury Field, 1805-1900", *Connecticut Historical Society
Bulletin*, vol. 28, no. 4, Oct. 1963, p.126, no. 229.

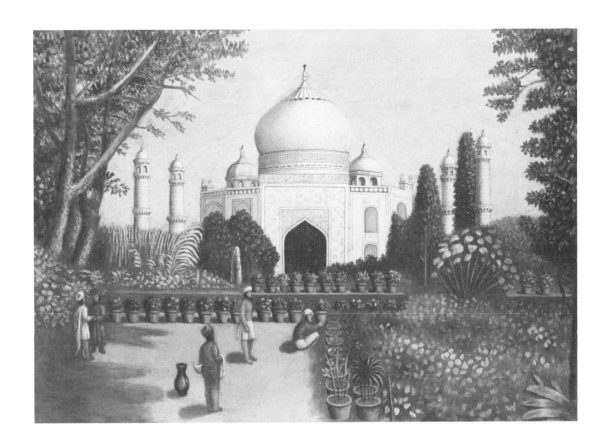

Catalogue no. 36

Unknown

By the Cool and Shady Rill ca. 1850

oil on canvas 46.5 x 61.1 cm
unsigned

PROVENANCE:
New York; Argosy Gallery, New York, New York; purchased from Argosy Gallery by Edgar William and Bernice Chrysler Garbisch, October 27, 1952 (Garbisch 52.91 also X1214); Flint Institute of Arts, December 1972.
FIA 72.71

CONDITION:
Cleaned, relined and in-painted by Alberto Angeli, 1963.

FRAME:
contemporary 5.1 x 3.1 cm
The face is gilded, the outside edge painted an ochre tone.

EXHIBITIONS:
New York, American Federation of Arts, *101 Masterpieces of American Primitive Painting from the Collection of Edgar William and Bernice Chrysler Garbisch,* New York, The Metropolitan Museum of Art, Nov. 17, 1961 - Jan. 7, 1962, Minneapolis, Walker Art Center, Feb. 10 - Mar. 11, 1962, Columbus Gallery of Fine Arts, Mar. 30 - Apr. 30, 1962, City Art Museum of St. Louis, May 15 - June 17, 1962, Los Angeles, Municipal Art Gallery, June 28 - July 30, 1962, San Francisco, M. H. de Young Memorial Museum, Aug. 15 - Sept. 15, 1962, Atlanta Art Association Galleries, Oct. 14 - Nov. 14, 1962, Richmond, Virginia Museum of Fine Arts, Dec. 7-30, 1962, Cincinnati Art Museum, Jan. 15 - Feb. 12, 1963, The Art Institute of Chicago, Feb. 28 - Mar. 31, 1963, Pittsburgh, Carnegie Institute, Apr. 16 - May 15, 1963, Fort Worth, Amon Carter Museum of Western Art, May 30 - June 30, 1963, Memorial Art Gallery of the University of Rochester, July 15 - Aug. 15, 1963, Milwaukee Art Center, Sept. 5-30, 1963, New Orleans, Isaac Delgado Museum of Art, Oct. 15 - Nov. 17, 1963, Baltimore Museum of Art, Dec. 1-30, 1963, Philadelphia Museum of Art, Jan. 15 - Feb. 15, 1964, Museum of Fine Arts Boston, March 5-29, 1964, Detroit Institute of Arts, Apr. 14 - May 15, 1964, no. 83, color repr., pl.83; and *American Naive Paintings of the 18th and 19th Centuries 111 Masterpieces from the Collection of Edgar William and Bernice Chrysler Garbisch,* Paris, Grand Palais, Feb. 16 - Apr. 18, 1968, Berlin, Amerika House, May 3 - June 10, 1968, Spoleto, Palazzo Collicola, June 28 - July 14, 1968, London, Royal Academy of Arts, Sept. 6 - Oct. 20, 1968, Brussels, Palais des Beaux-Arts, Nov. 7 - Dec. 29, 1968, Madrid, Cason del Buen Ritiro, Jan. 15 - Feb. 16, 1969, Barcelona, Palacio de la Virreina, Feb. 21 - Mar. 16, 1969, Montreal Museum of Fine Arts, Mar. 24 - Apr. 27, 1969, Washington, D.C., National Gallery of Art, June 12 - Sept. 1, 1969, New York, Whitney Museum of American Art, Sept. 15 - Nov. 2, 1969, The Museum of Fine Arts, Houston, Nov. 16, 1969 - Jan. 4, 1970, West Point, United States Military Academy Library, Jan. 22 - Feb. 15, 1970, Tokyo, Nihombashi Mitsukoshi, Sept. 3-20, 1970, no. 83, repr.; Frankenmuth (Michigan) Historical Museum, *American Naive,* Aug. 7 - Sept. 29, 1974; Battle Creek Civic Art Center, *Heritage of American Art,* Oct. 5-30, 1975, no. 26; Detroit, Michigan Artrain, Inc., *A Celebration of the Creative American Spirit,* Michigan Tour, June 2 - Dec. 15, 1976.

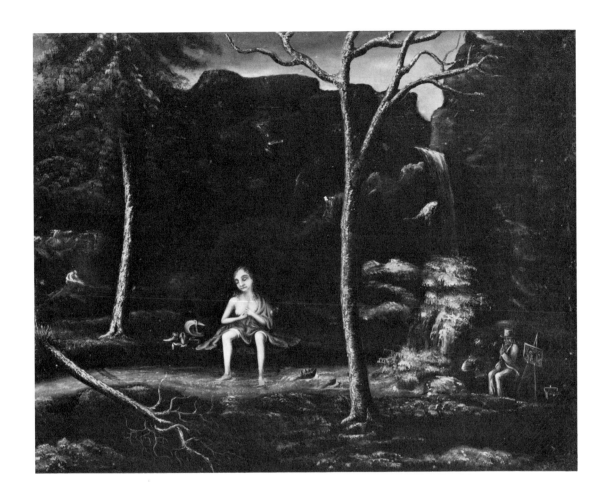

Catalogue no. 37

Unknown

Western Frontier Homestead ca. 1850
(verso of the original canvas bears, by the same hand, a copy of Benjamin West's *Portrait of Robert Fulton*, 1806, New York State Historical Association, Cooperstown)

oil on canvas 77.4 x 92.5 cm
unsigned

PROVENANCE:
Mystic, Connecticut; New York; Walter Wallace, New York, New York; purchased from Wallace by Edgar William and Bernice Chrysler Garbisch, August 7, 1956 (Garbisch 56.73 also Gar 527 and X851); Flint Institute of Arts, December 1968. FIA 68.27

CONDITION:
Cleaned, relined and in-painted by Paul P. Kiehart, 1957.

FRAME:
contemporary 7.6 x 3.8 cm
The face is gilded, its ridges finely reeded in a wave pattern and darkened. The outside edge is painted a sienna tone.

EXHIBITIONS:
Washington, D.C., National Gallery of Art, *American Primitive Paintings from the Collection of Edgar William and Bernice Chrysler Garbisch Part II*, Mar. 16 - Apr. 28, 1957, p.79, repr.; Washington, D.C., National Gallery of Art, on loan, 1957-1968; Detroit, Michigan Artrain, Inc., *A Celebration of the Creative American Spirit*, Michigan Tour, June 2 - Dec. 15, 1976.

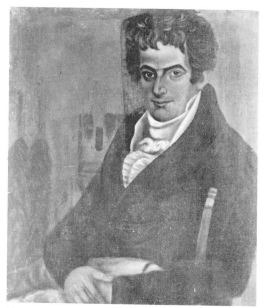

Verso of original canvas

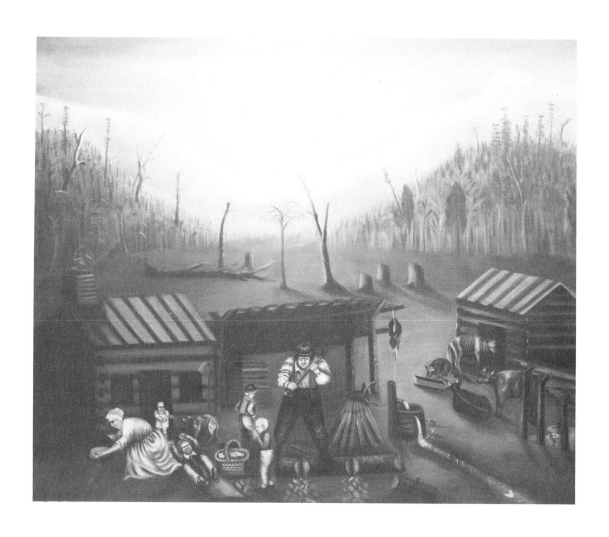

Catalogue no. 38

M. O'Neil

Civil War Encampment ca. 1863

oil on canvas 63.4 x 94.2 cm
signed lower left: M O Neil

PROVENANCE:
Massachusetts; Victor D. Spark, New York, New York; purchased from Spark by Edgar William and Bernice Chrysler Garbisch, December 8, 1955 (Garbisch 55.75 also Gar 517 and X815); Flint Institute of Arts, December 1968.
FIA 68.26

CONDITION:
Cleaned, relined and in-painted by Sheldon Keck, 1956.

FRAME:
contemporary 8.3 x 3.8 cm
The two-part molding is rosewood veneer, the liner gilded.

EXHIBITIONS:
Washington, D.C., National Gallery of Art, *American Primitive Paintings from the Collection of Edgar William and Bernice Chrysler Garbisch Part II*, Mar. 16 - Apr. 28, 1957, p.95, repr.; Washington, D.C., National Gallery of Art, on loan, 1957-1968; Frankenmuth (Michigan) Historical Museum, *American Naive*, Aug. 7 - Sept. 29, 1974; Detroit, Michigan Artrain, Inc., A *Celebration of the Creative American Spirit*, Michigan Tour, June 2 - Dec. 15, 1976.

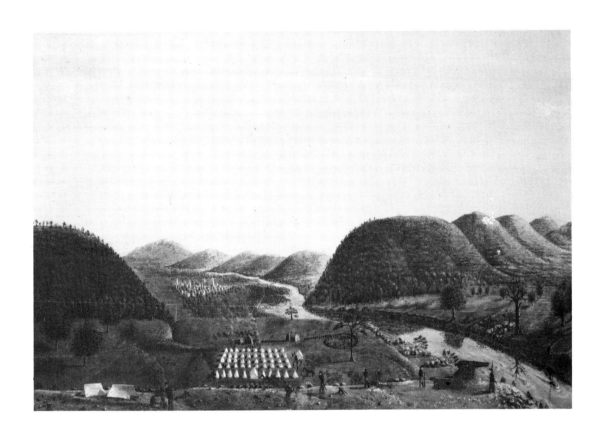

Catalogue no. 39

Unknown

Fruit in Wicker Basket on Brown Table ca. 1870

oil on canvas 61 x 91.6 cm
unsigned

PROVENANCE:
Higginsville, New York; Robert Bishop; purchased
from Bishop by Edgar William and Bernice Chrysler
Garbisch, January 15, 1964 (Garbisch 64.6 also
X1258); Flint Institute of Arts, December 1973.
FIA 73.93

CONDITION:
Cleaned, relined, adhered to a honeycomb panel and
in-painted by Paul P. Kiehart, 1966.

FRAME:
contemporary 9.4 x 6.5 cm
The face and outside edge are gilded.

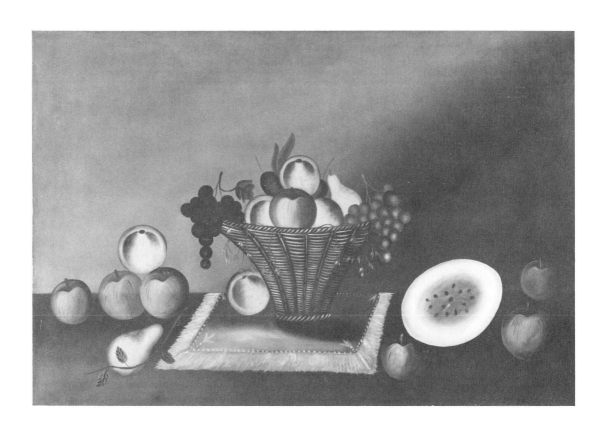

Catalogue no. 40

Bibliography

Abby Aldrich Rockefeller Folk Art Collection. *The Abby Aldrich Rockefeller Folk Art Collection: A Descriptive Catalogue.* Catalogue by Nina Fletcher Little. Williamsburg: Colonial Williamsburg, 1957.

Abby Aldrich Rockefeller Folk Art Collection. *American Folk Portraits.* Foreword by Beatrix T. Rumford, Introduction by Donald R. Walters and Carolyn J. Weekley. Boston: New York Graphic Society, 1981.

Abby Aldrich Rockefeller Folk Art Collection. *Edward Hicks 1780-1849, A Special Exhibition Devoted to His Life and Work.* Introduction and Chronology by Alice Ford, Catalogue by Mary Black. Williamsburg: Colonial Williamsburg, 1960.

Allen, Edward B. *Early American Wall Paintings, 1710-1850.* New Haven: Yale University Press, 1926.

Black, Mary and Lipman, Jean. *American Folk Painting.* New York: Clarkson N. Potter, 1966.

Bolton, Theodore. *Ezra Ames of Albany, Portrait Painter, Craftsman, Royal Arch Mason, Banker, 1768-1836.* Catalogue by Irwin F. Cortelyou with Theodore Bolton. New York: New York Historical Society, 1955.

Burroughs, Alan. *Limners and Likenesses; Three Centuries of American Painting.* Cambridge: Harvard University Press, 1936.

Cahill, Holger. *American Folk Art, The Art of the Common Man in America 1750-1900.* New York: W.W. Norton, 1932.

Chicago Historical Society. *American Primitive Painting, 19th Century, The Chicago Historical Society's Collection.* Chicago: Chicago Historical Society, 1950.

Colonial Williamsburg. *A Catalogue of the American Folk Art Collection of Colonial Williamsburg.* Catalogue by Edith Gregor Halpert. Williamsburg: Colonial Williamsburg, 1947.

Department of Fine Arts, Carnegie Institute. *American Provincial Paintings from the Collection of J. Stuart Halladay and Herrel George Thomas.* Pittsburgh: Carnegie Institute, 1941.

Dewhurst, C. Kurt; MacDowell, Betty and MacDowell, Marsha. *Artists in Aprons: Folk Art by American Women.* New York: Museum of American Folk Art, 1979.

Dunlap, William. *A History of the Rise and Progress of the Arts of Design in the United States.* new ed. Edited and Additions by Frank W. Bayley and Charles E. Goodspeed. 3 vols. Boston: C.E. Goodspeed, 1918.

Ebert, John and Ebert, Katherine. *American Folk Painters.* New York: Scribner's, 1975.

Field, Erastus Salisbury. *Descriptive Catalogue of the Historical Monument of the American Republic.* Amherst: H.H. McCloud, 1876.

Fielding, Mantle. *Dictionary of American Painters, Sculptors and Engravers.* Philadelphia: for the subscribers, 1926; 3rd ed. Edited with Additions by James F. Carr. New York: J.F. Carr, 1965.

Ford, Alice. *Edward Hicks, Painter of The Peaceable Kingdom.* Philadelphia: University of Pennsylvania Press, 1952.

_____ . *Pictorial Folk Art New England to California.* New York: Studio Publications, 1949.

Garbisch, Edgar William and Garbisch, Bernice Chrysler (with nine other authors). "American Primitive Paintings, Collection of Edgar William and Bernice Chrysler Garbisch," *Art in America,* vol. 42, no. 2 (May 1954), special issue.

[Garbisch] *American Primitive Paintings from the Collection of Edgar William and Bernice Chrysler Garbisch, Part I* and *Part II.* Washington, D.C.: National Gallery of Art, 1954 and 1957.

[Garbisch] *101 Masterpieces of American Primitive Painting from the Collection of Edgar William and Bernice Chrysler Garbisch.* Foreword by James J. Rorimer, Preface by John Walker, Introduction by Albert Ten Eyck Gardner. New York: American Federation of Arts, 1961; new ed. New York: American Federation of Arts, 1962.

[Garbisch] *101 American Primitive Watercolors and Pastels from the Collection of Edgar William and Bernice Chrysler Garbisch.* Foreword by John Walker, Introduction by William S. Campbell. Washington, D.C.: National Gallery of Art, 1966.

[Garbisch] *American Naive Painting of the 18th and 19th Centuries from the Collection of Edgar William and Bernice Chrysler Garbisch.* Foreword by Gabriel White, Introduction by Robert Melville. London: Arts Council of Great Britian, 1968.

[Garbisch] *Peintures naives américaines; Amerikaanse naïeve schilderijen.* Foreword by Jean Chatelain, Preface by John Walker, Introduction by Albert Ten Eyck Gardner. Brussels: Palais des Beaux-Arts; Paleis voor Schone Kunsten, 1968.

[Garbisch] *American Naive Painting of the 18th and 19th Centuries: 111 Masterpieces from the Collection of Edgar William and Bernice Chrysler Garbisch.* Foreword by John Walker, Preface by Lloyd Goodrich, Introduction by Albert Ten Eyck Gardner. New York: American Federation of Arts, 1969.

Groce, George Cuthbert and Wallace, David H. *The New York Historical Society's Dictionary of Artists in America 1564-1860.* New Haven: Yale University Press, 1957.

Halpert, Edith Gregor, ed. *American Folk Art.* Williamsburg: Colonial Williamsburg, 1940.

Janis, Sidney. *They Taught Themselves; American Primitive Painters of the Twentieth Century.* Foreword by Alfred H. Barr, Jr. New York: Dial Press, 1942.

[Karolik] M. *and* M. *Karolik Collection of American Paintings 1815-1865.* 2 vols. Boston: Museum of Fine Arts, 1949.

[Karolik] M. *and* M. *Karolik Collection of American Watercolors and Drawings 1800-1875.* Boston: Museum of Fine Arts, 1962.

Lipman, Jean. *American Primitive Painting.* New York: Oxford University Press, 1942; reprint ed. New York: Dover, 1972.

_____ and Meulendyke, Eve. *American Folk Decoration.* New York: Oxford University Press, 1951.

_____ and Winchester, Alice. *The Flowering of American Folk Art: 1776-1876.* New York: Viking Press with Whitney Museum of American Art, 1974.

_____ and Winchester, Alice, eds. *Primitive Painters in America: 1750-1950.* New York: Dodd Mead, 1950; reprint ed. Freeport: Books for Libraries Press, 1971.

Little, Nina Fletcher. *American Decorative Wall Painting 1700-1850.* Sturbridge: Old Sturbridge Village, 1952; rev. ed. New York: Dutton, 1972.

_____ . *Country Art in New England, 1790-1840.* 1960; rev. ed. Sturbridge: Old Sturbridge Village, 1965.

Museum of Modern Art. *American Folk Art, The Art of the Common Man in America, 1750-1900.* Introduction by Holger Cahill. New York: Museum of Modern Art, 1932.

New York Historical Society. *Catalogue of American Portraits in the New York Historical Society.* Catalogue by Donald A. Shelley. New York: New York Historical Society, 1941.

Sawitsky, William. *Catalogue, Descriptive and Critical, of the Paintings and Miniatures in the Historical Society of Pennsylvania.* Philadelphia: Historical Society of Pennsylvania, 1942.

Sommer, Frank H. *Pennsylvania German Prints, Drawings and Paintings, a Selection from the Winterthur Collection.* Winterthur: Henry Francis du Pont Winterthur Museum, 1965.

Stoudt, John Joseph. *Early Pennsylvania Arts and Crafts.* New York: A.S. Barnes, 1964.

_____ . *Pennsylvania Folk Art; An Introduction.* Allentown: Pennsylvania German Folklore Society, 1948.

[Tillou] *Nineteenth-Century Folk Painting, Our Spirited National Heritage: Selections from the Collection of*

Mr. and Mrs. Peter Tillou. Storrs: William Benton Museum of Art, University of Connecticut, 1973.

Woodward, Richard B. *American Folk Painting from the Collection of Mr. and Mrs. William E. Wiltshire III.* Introduction by Mary Black. Richmond: Virginia Museum, 1977.